photographs
by ernestine ruben

in human touch

James Christen Steward, *Editor*

With essays by
Lyle Rexer
James Christen Steward
Serge Tisseron

Nazraeli Press
in association with
The University of Michigan
Museum of Art

Published on the occasion of the exhibition
In Human Touch: Photographs by Ernestine Ruben,
organized by The University of Michigan Museum of Art
June 10–September 23, 2001

The photographs in this publication have been provided
by the owners or custodians of the works and are repro-
duced with their permission.

Designer: Steven Driscoll Hixson
Editor: Karen Chassin Goldbaum

Nazraeli Press
ISBN: 1-59005-008-8

Printed in China

in human touch

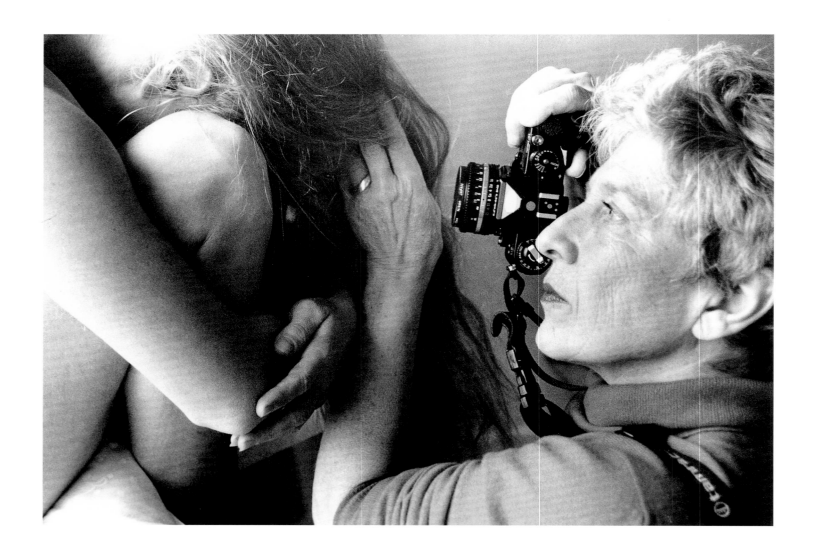

contents

 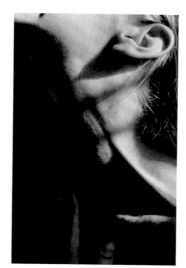 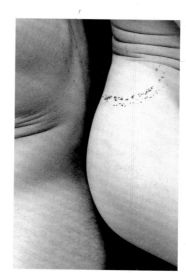

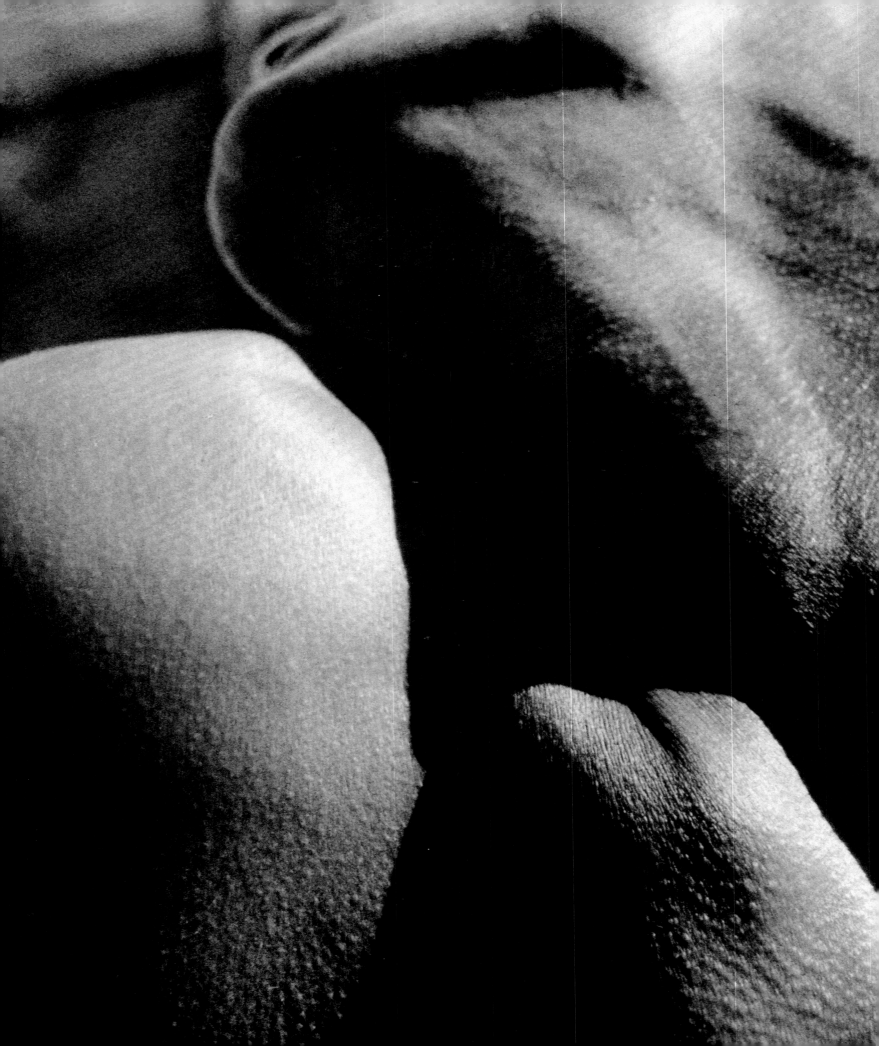

acknowledgments

This project—both as a publication and a traveling exhibition—first began when I met Ernestine Ruben in early 2000. I liked her immediately, for her personal warmth, her passion for photography, her proselytizing nature. She is a born teacher, eager to make converts to the cause, and she converted me to her passion for platinum and gum bichromate printing—methods out of fashion since the 1920s—at our first encounter. And of course I liked her for the images she has made, over which we poured on subsequent visits together. The fact that she is also a distinguished alumna of the University of Michigan may have been what brought us together, but it alone did little to motivate either this project or our friendship. For these, I can only be grateful to Ernie for her many gifts. My very first thanks must go to the artist—for the remarkable body of work she has crafted, for her exceptional generosity in getting it into the world, for attending with such care to every detail on which we asked her to focus, and for otherwise stepping back and giving us room to create a study and an exhibition of her achievement that would have to rest on their own merits. Throughout the past eighteen months, I have benefited from her exceptional hospitality and boundless kindnesses, as well as those of her husband Herb, in both Princeton and New York.

In Human Touch has come to fruition in very short order, relative to the ways in which art books and exhibitions often take form. Many motivated individuals have made this possible. First, I must thank Chris Pichler at Nazraeli Press for his longstanding enthusiasm for the artist's work, his eagerness to work with a new institutional partner, and his willingness to give us so much room to make this book. Such trust on the part of a publisher is rare and exemplary. Similarly, thanks are due to John Stevenson, director of the John Stevenson Gallery in New York and an important advocate for both the work of Ernestine Ruben in particular and of platinum photography in general. I am also indebted to contributing writers Lyle Rexer and Serge Tisseron for their elegant and incisive additions to this volume— and for their consistent willingness to respond to enquiries with unusual speed.

At the University of Michigan Museum of Art, I am blessed with the support of a gifted and giving staff who are committed to excellence—and who go beyond the call of duty to turn this commitment into reality. First thanks are due to Steven Hixson, the Museum's talented Senior Designer who has also acted as designer for this publication. It has been a delight to share the development of this work with him, and to witness his passion for energized design, elegant type, and beautiful paper. Equally, thanks are due to Karen Goldbaum, Senior Editor, for shaping the texts that follow, for her ability to understand what was needed, her commitment to crisp and effective prose, and her tolerance for a director who can't resist continuing to dabble in curation. Without their considerable talents and energies this volume would not exist, and it should by rights belong to them. Elsewhere in the Museum, many talented individuals have given life to this project: Lori Mott, Registrar, for facilitating the transport of objects; Ann Sinfield, Collections and Exhibitions Assistant, for providing general support and for gathering the images needed for this publication; and to Kevin Canze, Kirsten Neelands, and Jaye Schlesinger, Preparators; for conceptualizing the exhibition's installation and giving care to detail that is worthy of the photographs themselves. Finally, deep gratitude is owed to the Friends of the Museum of Art, the Katherine Tuck Enrichment Fund, and other donors for their financial support and their commitment to making contemporary art a vibrant part of civic and individual life.

James Christen Steward
Director
University of Michigan Museum of Art

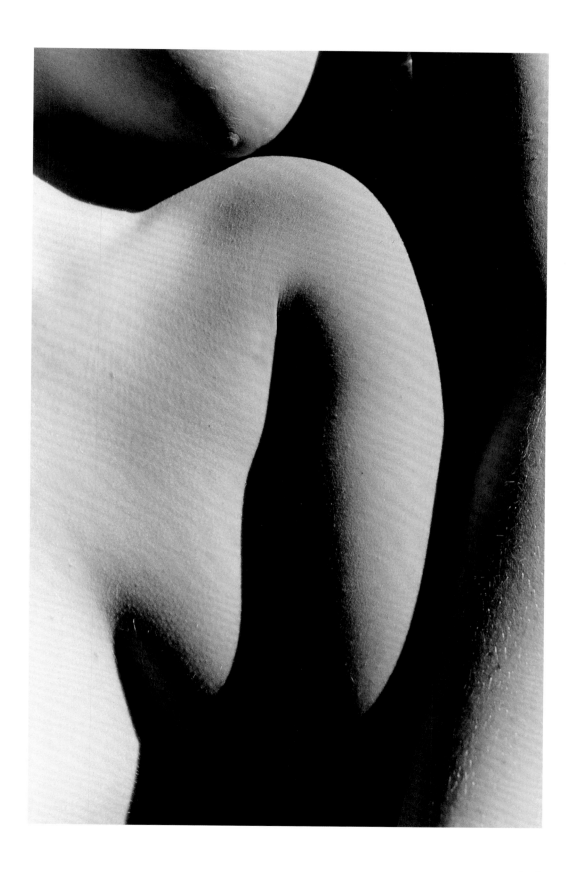

plate I

10

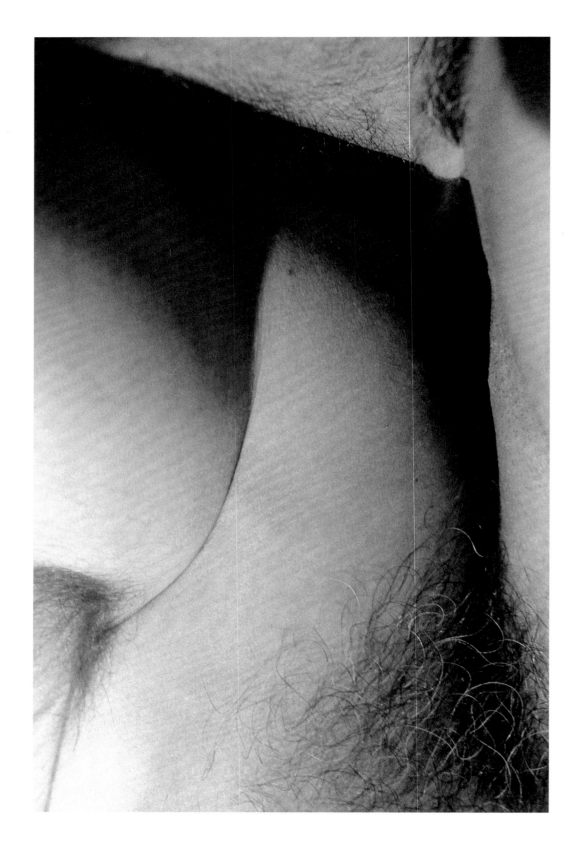

plate 2

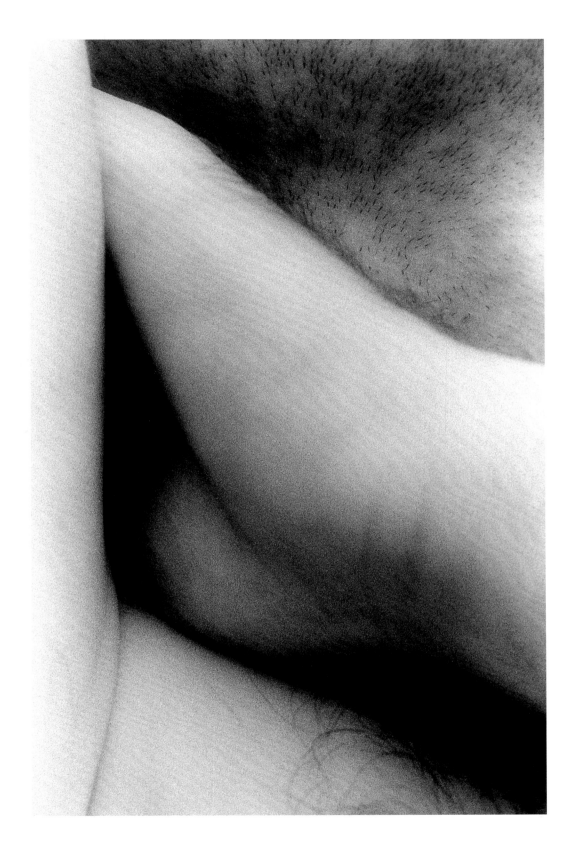

plate 3

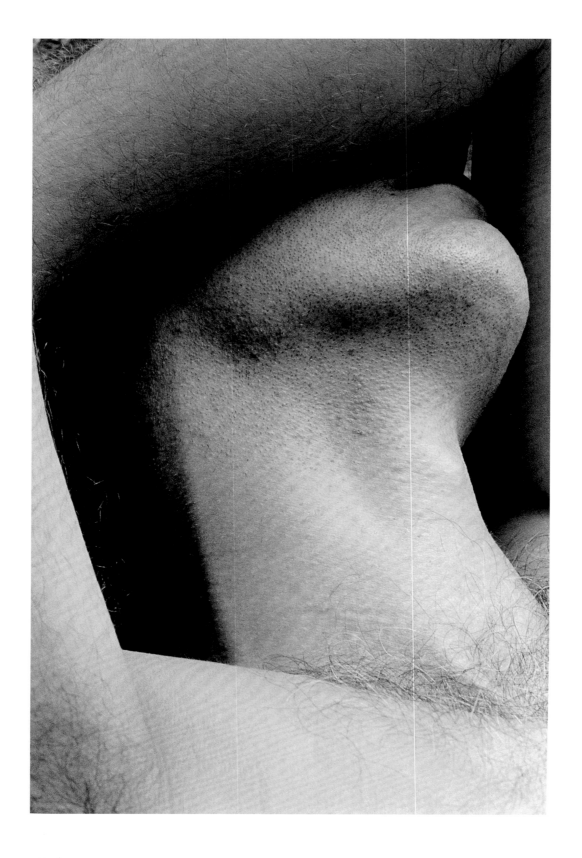

plate 4

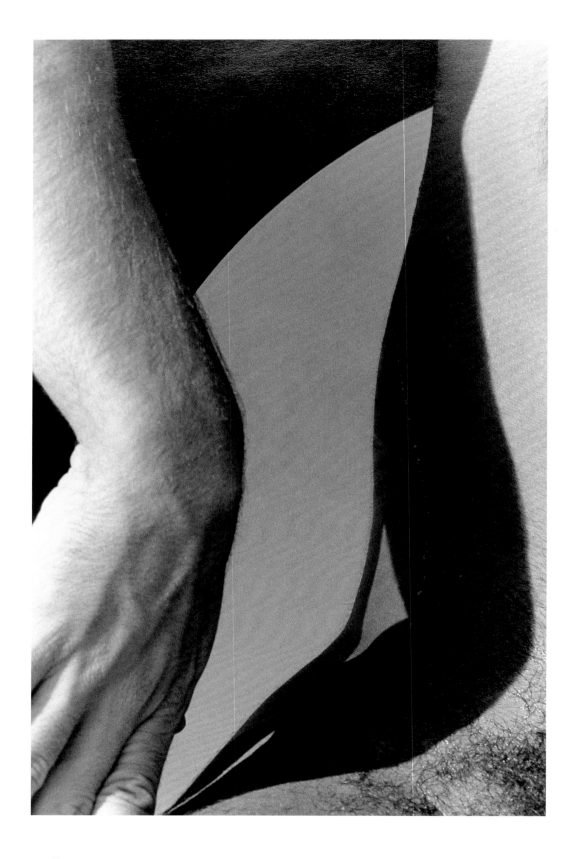

plate 5

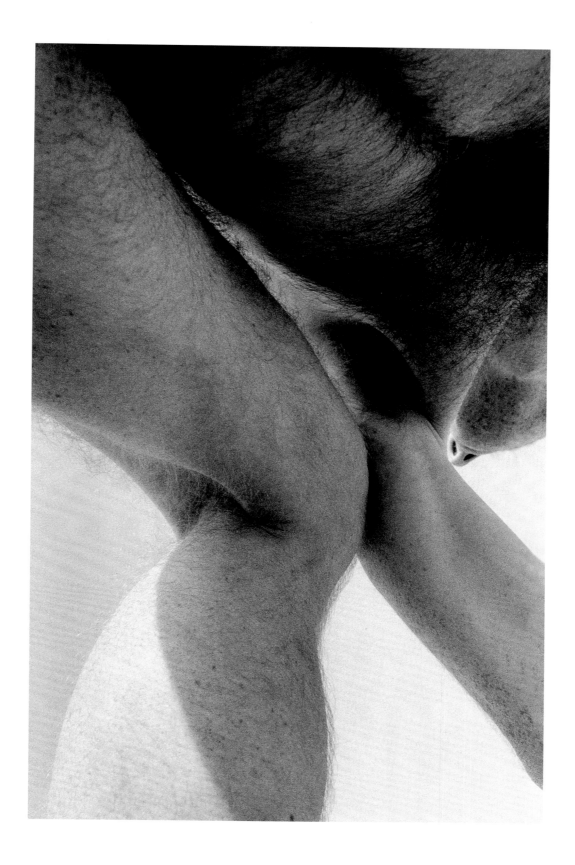

plate 6

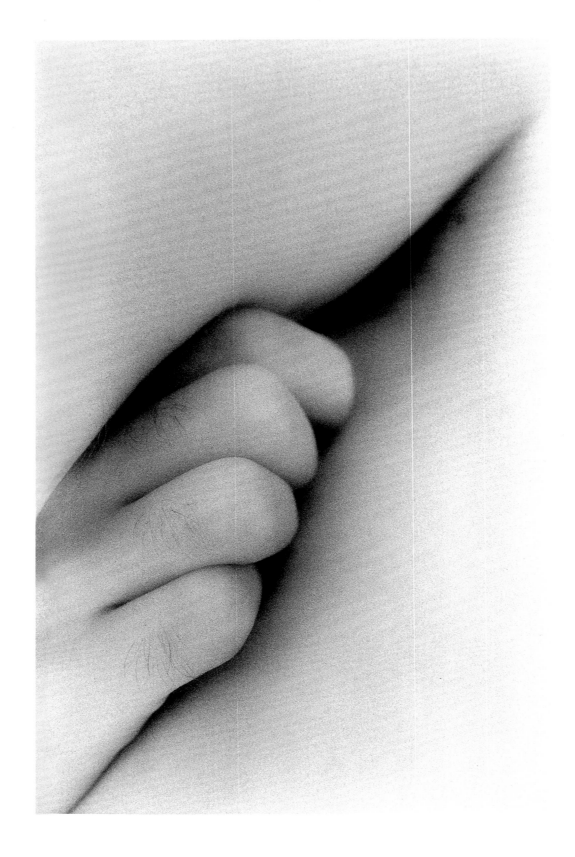

plate 7

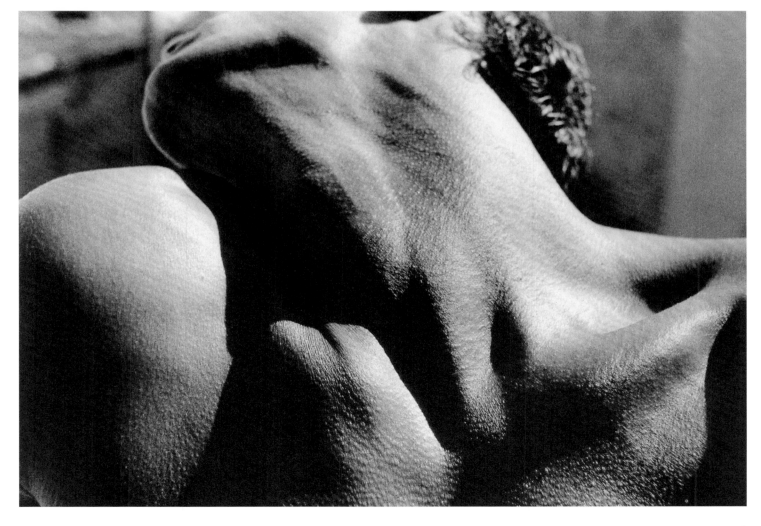

plate 8

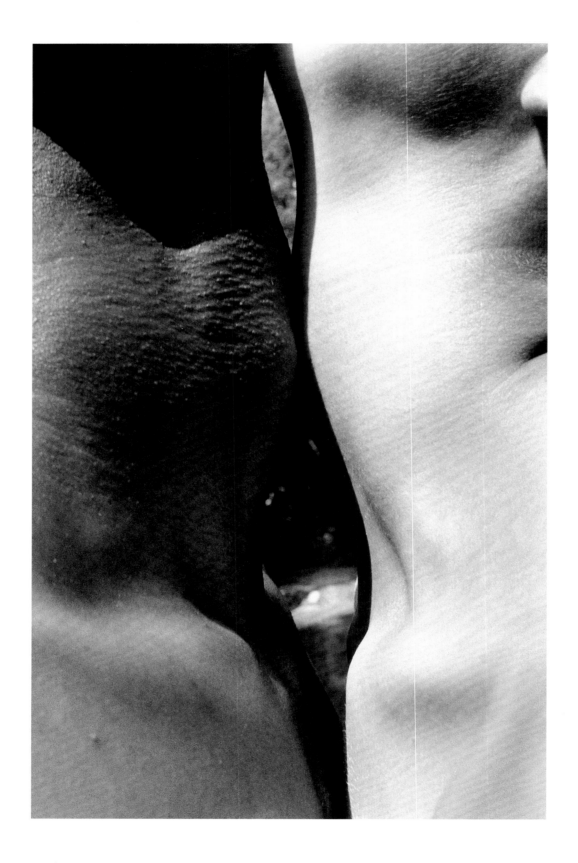

plate 9

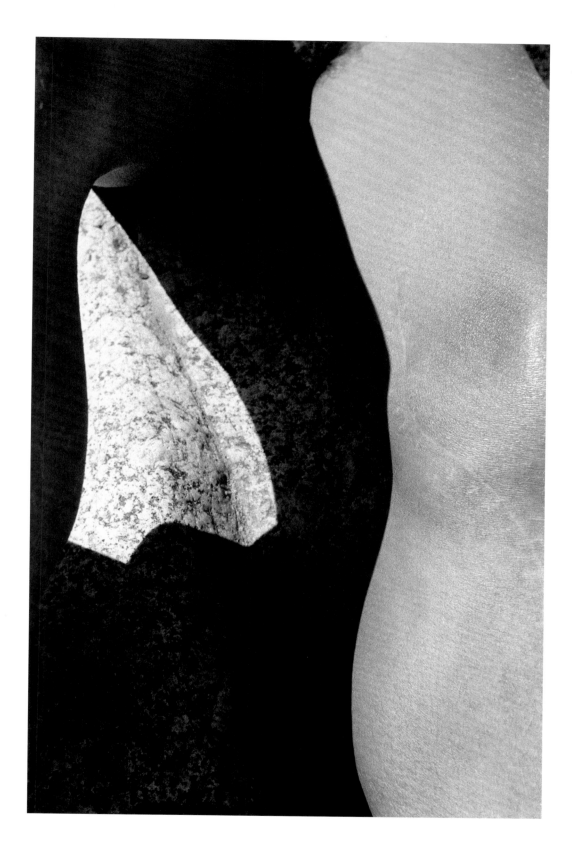

plate IO

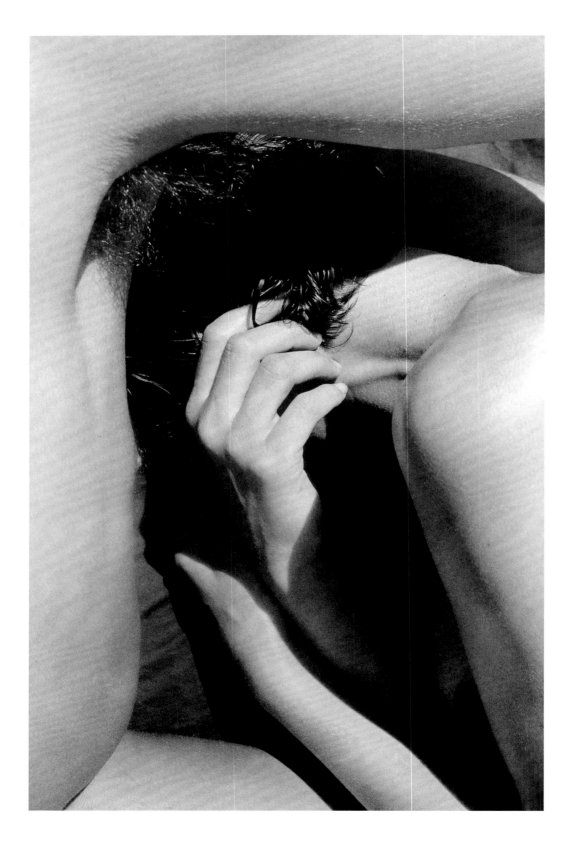

plate II

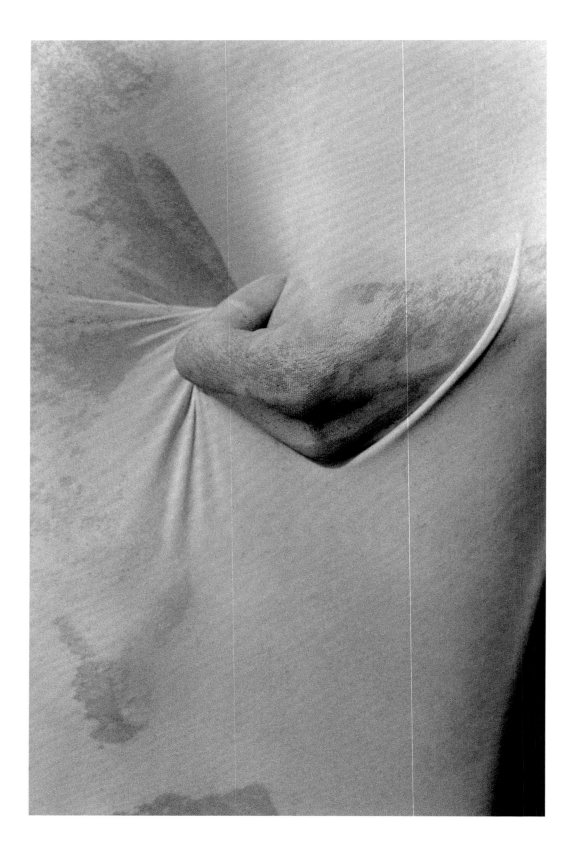

plate I2

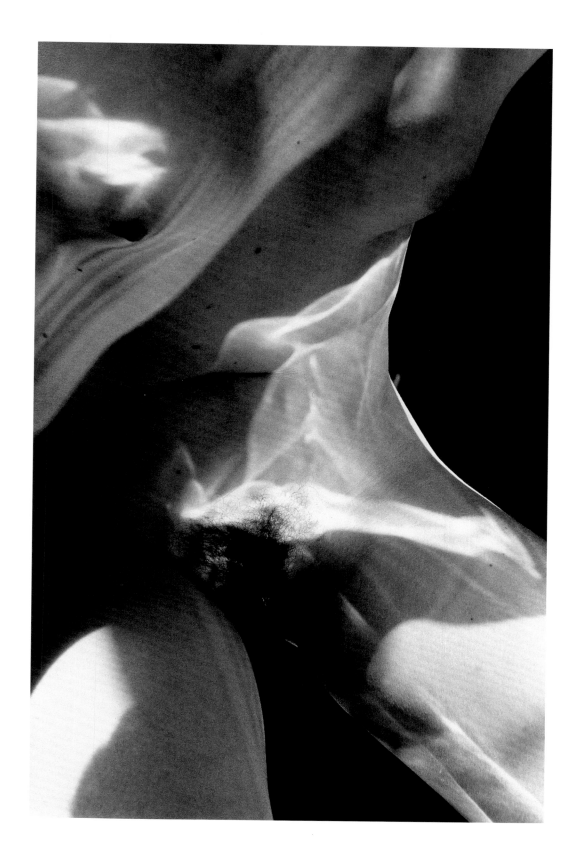

plate I3

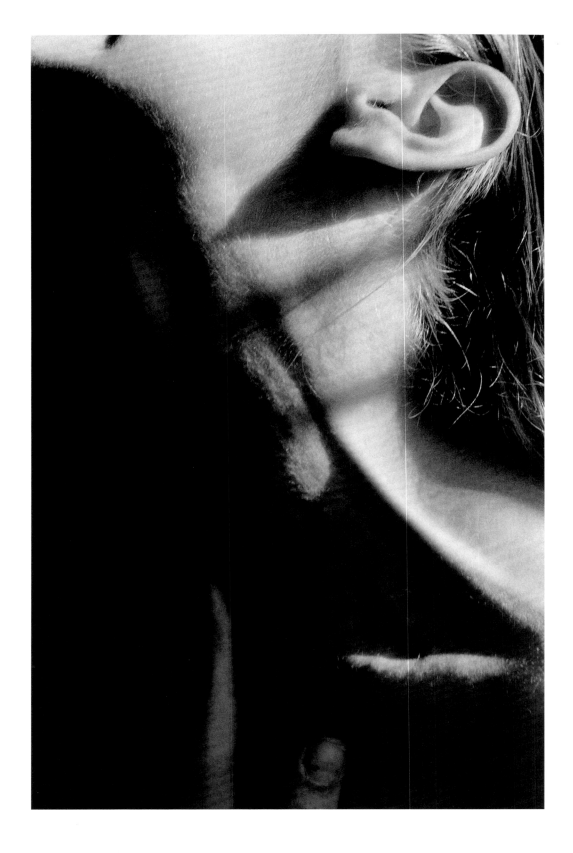

plate I4

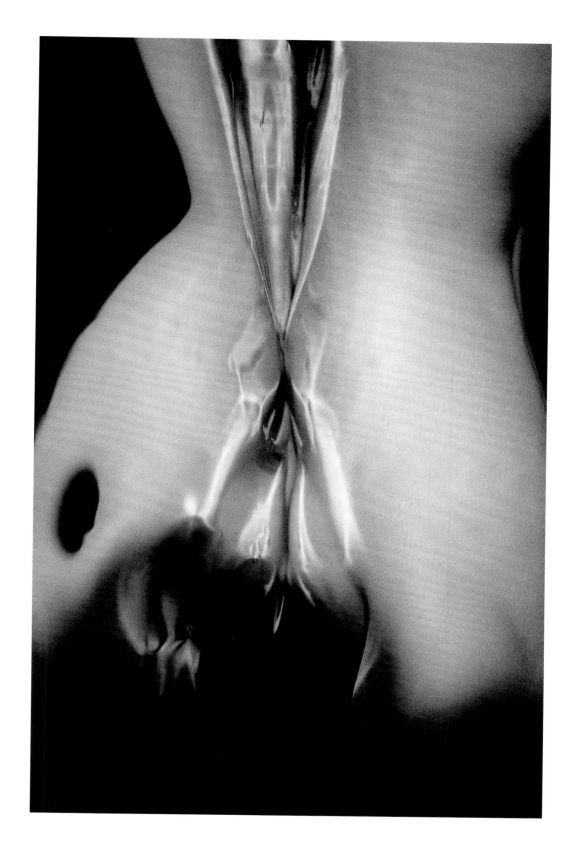

plate I5

28

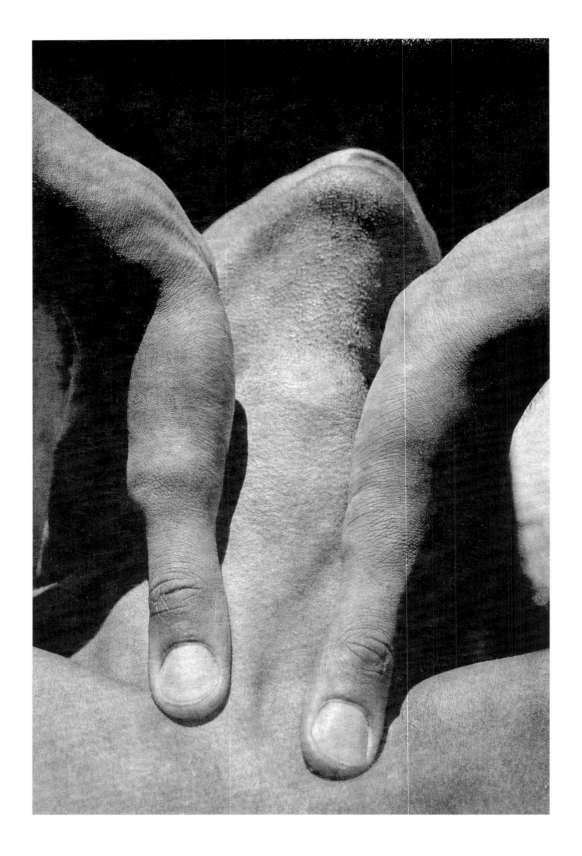

plate 16

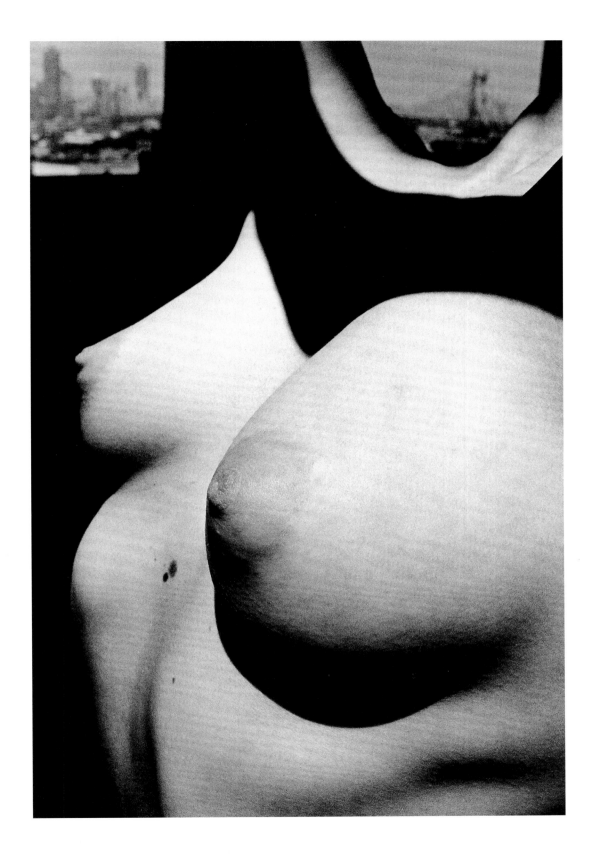

plate 17

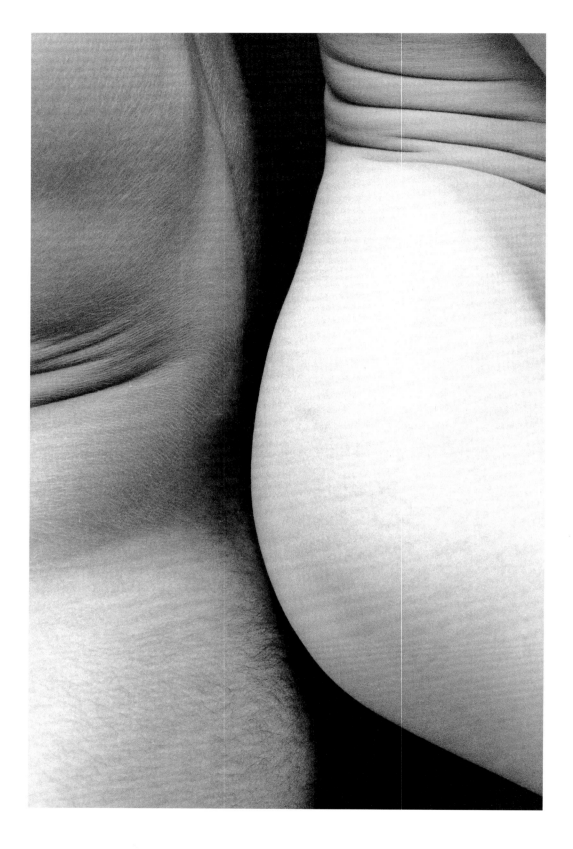

plate 18

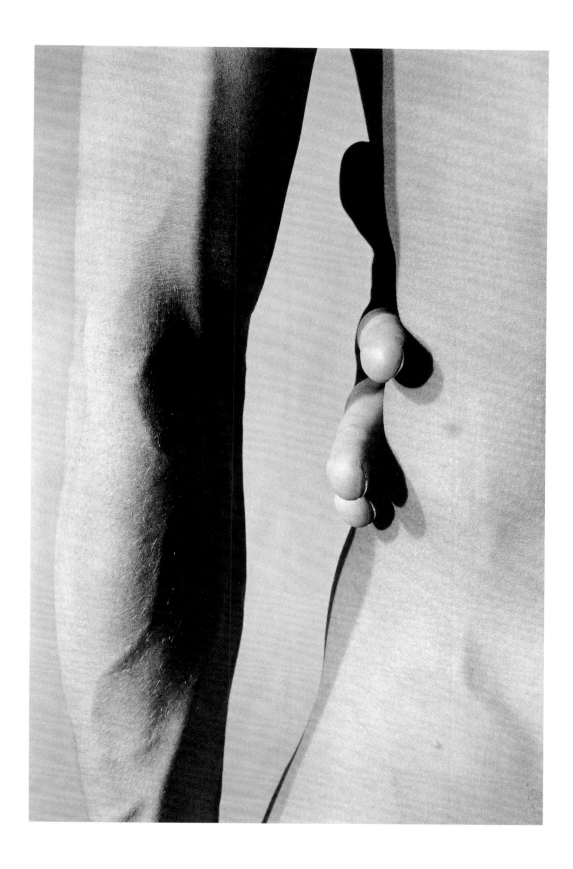

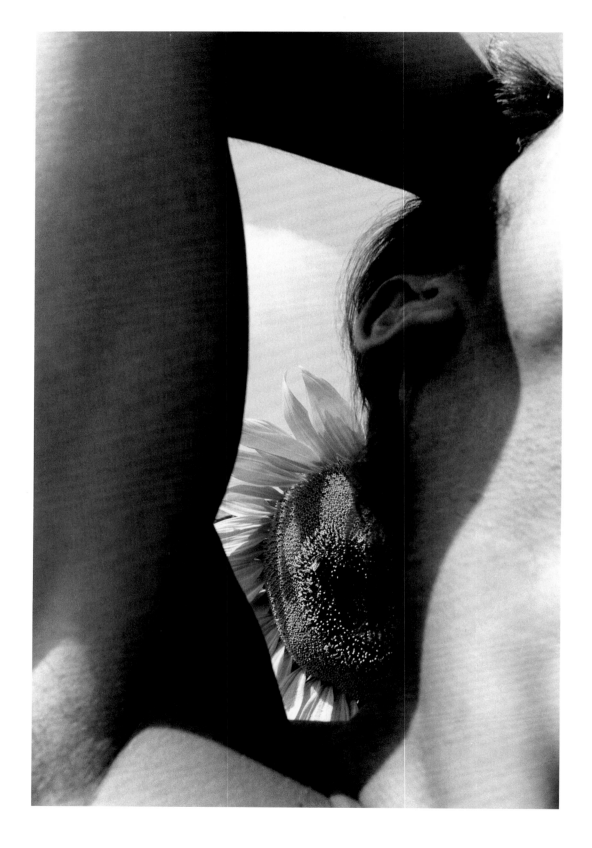

plate 20

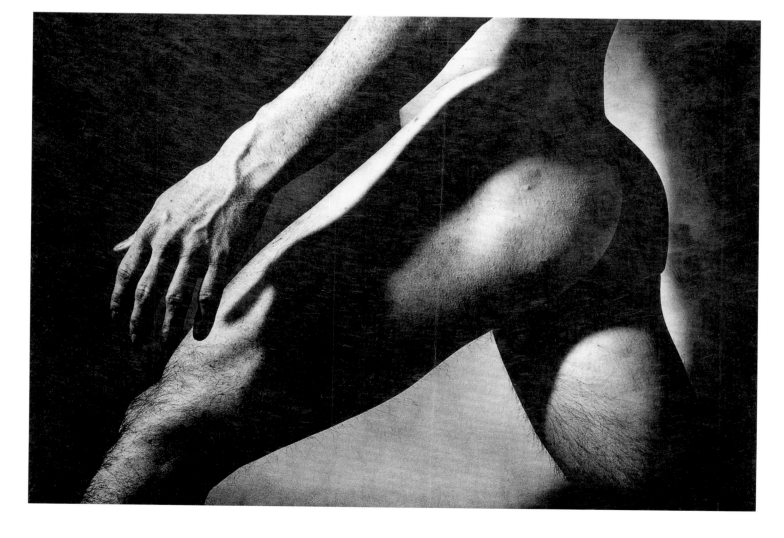

plate 21

40

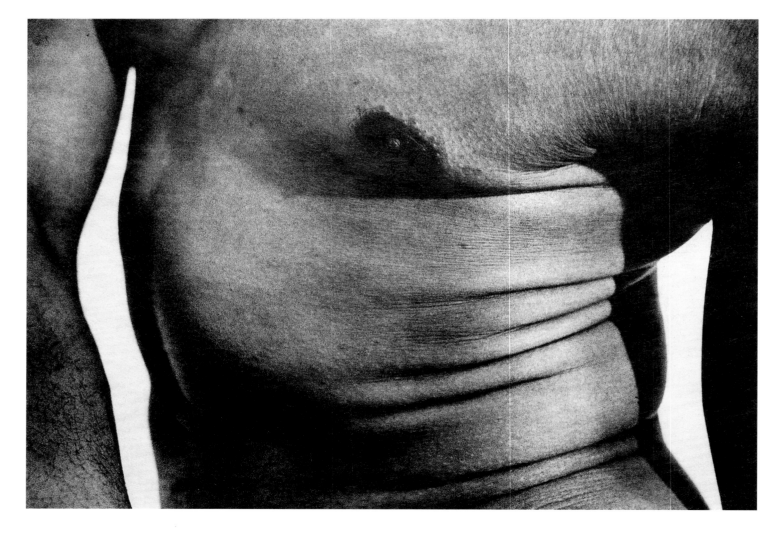

plate 22

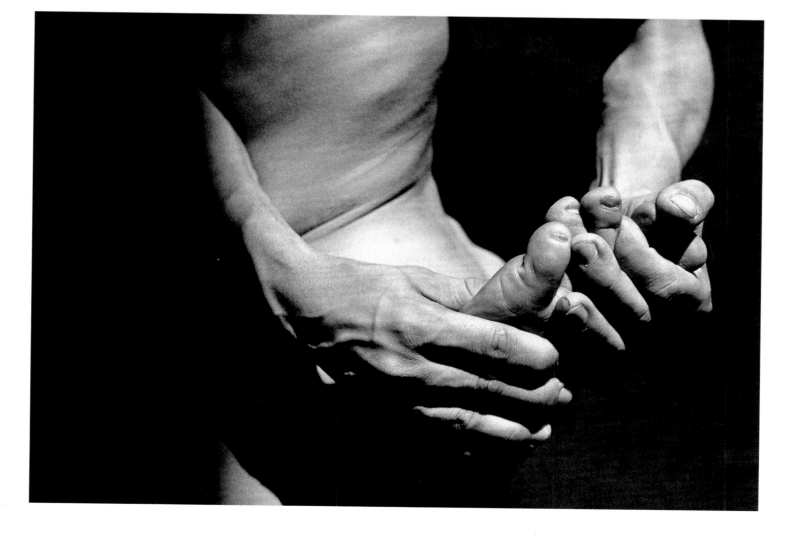

plate 23

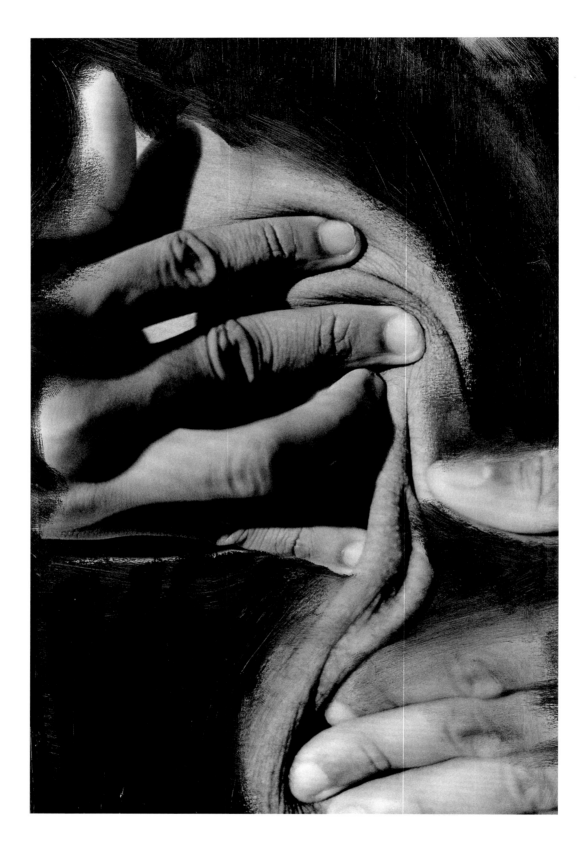

plate 24

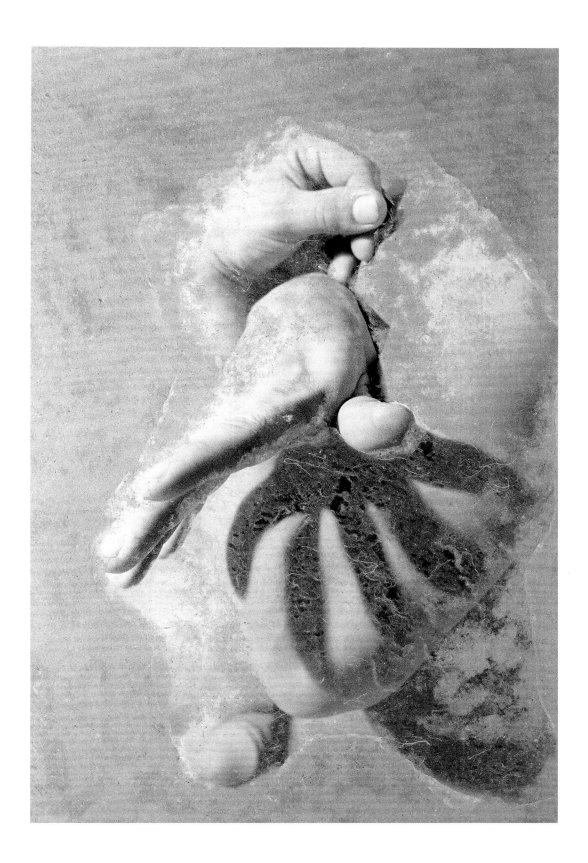

plate 25

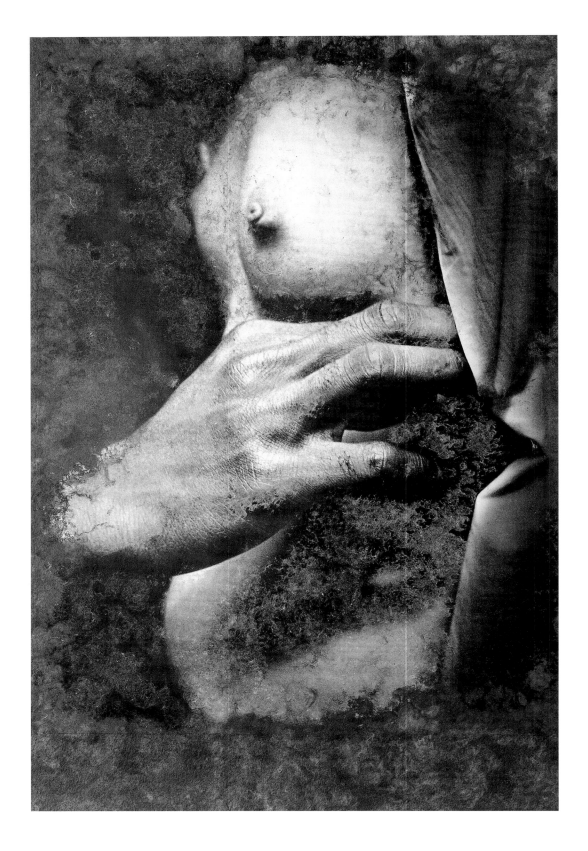

plate 26

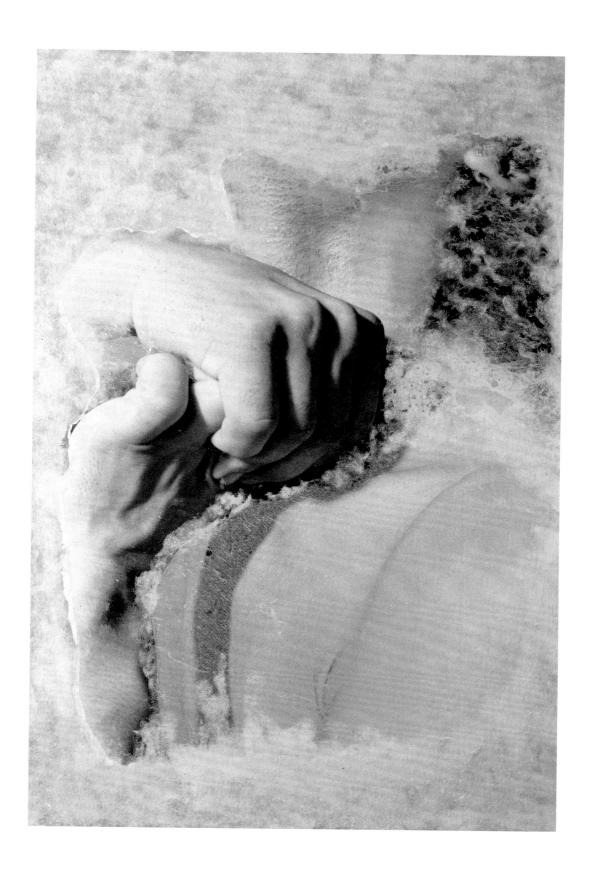

plate 27

50

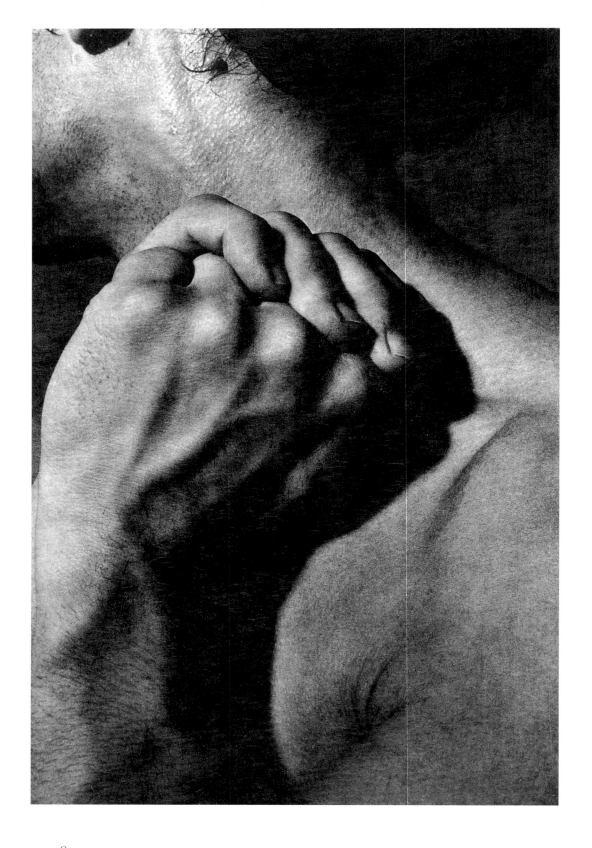

plate 28

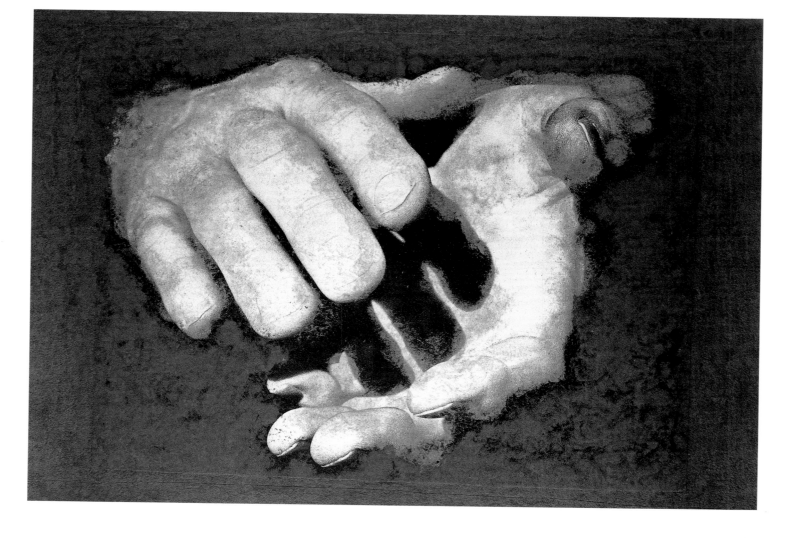

plate 29

54

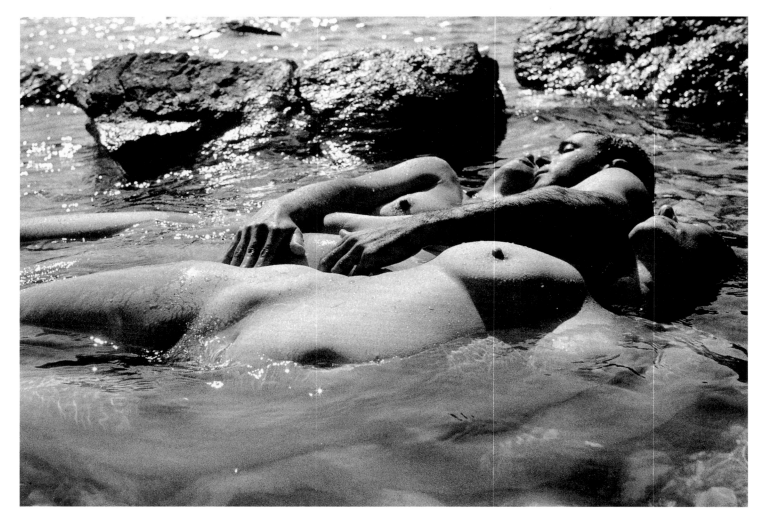

plate 30

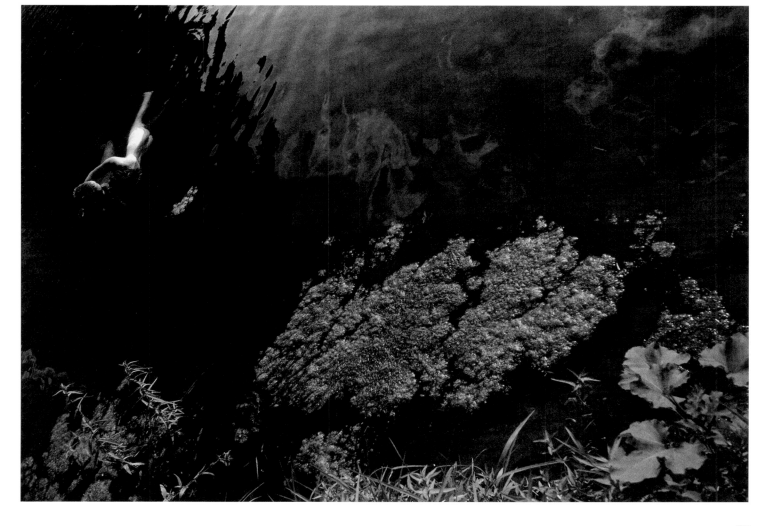

plate 31

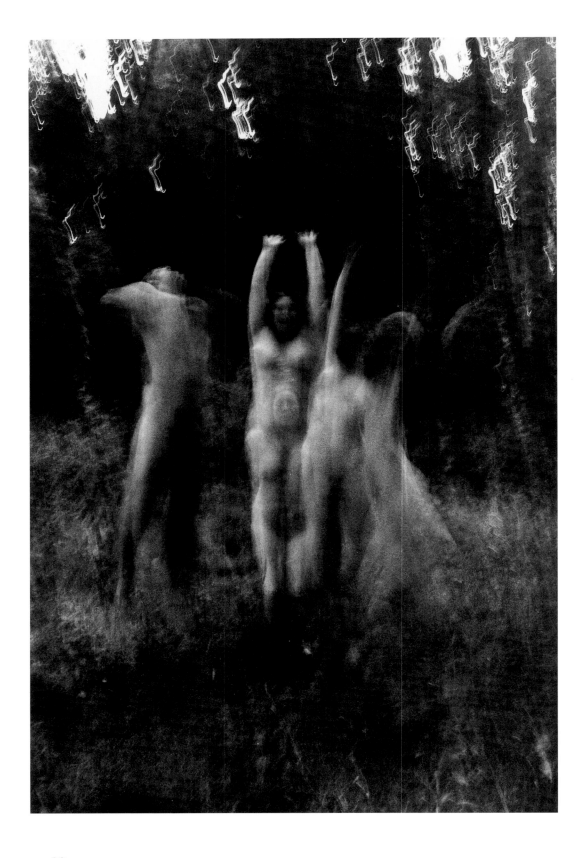

plate 32

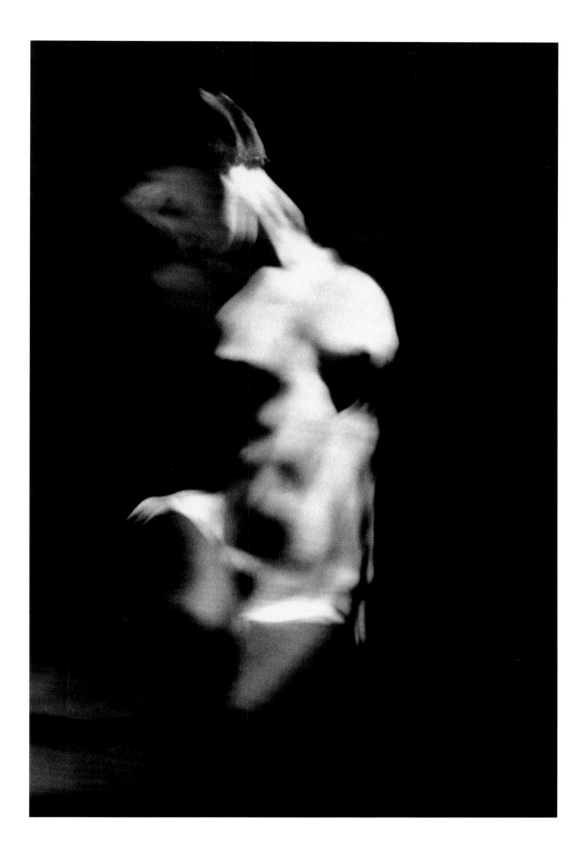

plate 33

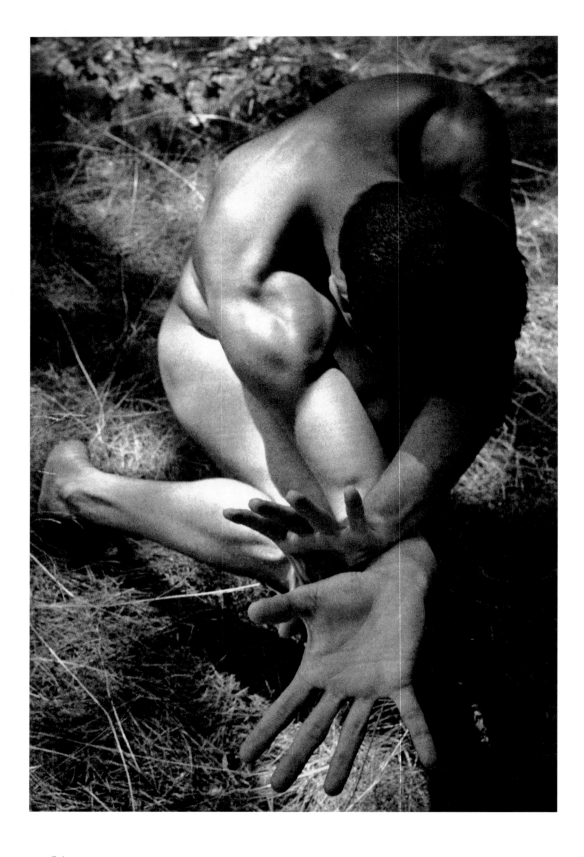

plate 34

For me,
art is all about process—

not technique, but process.

It is about the discovery of life, or energy.

It is the long (or short) trip

we take to engage our senses,

about feeling fulfilled, touched, stimulated.

It is about coming alive. **ernestine ruben**

formalist fragments and postmodern manipulations

james christen steward

In Georgian Britain, the noted portrait and landscape painter Thomas Gainsborough condemned his leading rival Sir Joshua Reynolds by once remarking how damnably varied he was. This was, of course, rather a profound compliment—and an accurate reflection, at that—of Reynolds's equal agility with formal portraiture, genre scenes, the landscape, and scenes drawn from the imagination. It was the sense that he excelled in all of these, thus leaving less of the playing field open to his rival to make his mark, that was at the heart of Gainsborough's remark. The photographs of Ernestine Ruben demand our attention, in part, for the same reason. Although as an artist she came late to fine art photography, she has in the subsequent twenty-plus years exhibited a restless reaching toward new subject matter, new means of expression, and an embrace of alternative and sometimes overlapping media. Ruben began with the human form, expressed in lyrically rendered details of the body that offer a kind of highly structured abstraction. Later, her work turned to an exploration of the body in motion—she has been noted to have a most profound understanding of movement for a non-choreographer—and to an investigation of the landscape, both built and natural, often infused with a sense of emotional atmosphere that looks back to an early generation of photographers, those working in the Pictorialist mode in the years surrounding the First World War. Some of her most successful images combine these interests, and turn to the sculptural body in the landscape—most notably in photographing the sculpture of Auguste Rodin in and around the Musée Rodin in Paris.

Throughout this trajectory, one senses a restlessness, a yearning to free herself from the traditional limitations of the photograph. It has of course been argued that the realism of the photograph—its capacity to capture the world in an unmediated way, as it really is—would be the death of painting. Perhaps for these reasons, the photograph was long resisted by museums and by serious collectors, until taken up by both with a passion in the early 1970s. In Ruben's case, the restlessness takes various forms: in some examples, one finds a tangible, even aggressive, desire to be liberated from the static and the two-dimensional—as in her *Round Brooklyn Bridge* (1986) and related kinetic works. In much of Ruben's recent work, particularly the images printed on paper pulp or those in the gum bichromate medium, she goes further, in an attempt to liberate the photograph from its own skin. Through complex and rigorous printing techniques, she creates layered images that reflect multiple skins gradually revealing themselves, or a sense of unearthings (if we think of this process going in the opposite direction) akin to the process of the archaeologist. Here, too, we find overlappings—the artist's desire to move beneath the surface, merged with the archaeologist's desire to unearth, and her perpetual interest in the sculptural. In images such as *Balzac's Head* (1998), we should not be surprised to see Ruben applying her technique to laboriously fabricated handmade paper and paper pulp, in which additional layers—the pulp of the paper fighting its totality—emerge, or to see this technique applied to sculptural and architectural subject matter such as the

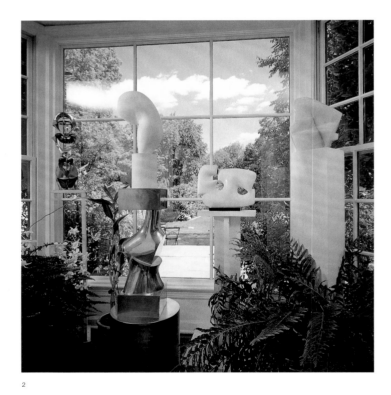

1 Albert Kahn residence, Albert Kahn Associates

2 Ruben Collection, including Hans Arp's *Dream Column* (center),
 installed in the Garden Room of the Rubens' Home, Princeton, New Jersey

3 **Edward Steichen** *Constantin Brancusi in his Studio*, ca. 1925, photogravure
 University of Michigan Museum of Art
 Gift of Frederick P. and Amy McCombs Currier

sculptural monuments of India. In images such as *Dark Twist* (1996), a platinum print on paper pulp, the warm tones of the platinum merge with the subject matter and the hand-made paper to create an object that is mysteriously archaeological.

The net trajectory of Ruben's work of the past twenty-five years is entirely the opposite of that of one of the great figures in fine art photography, and certainly a profound influence on Ruben, Edward Steichen. Steichen functionally began with a moody pictorialism, creating symphonic tone poems—of mist-shrouded New York streets, sculptures in the rising dawn (as in his *Balzac, The Silhouette –4 a.m.,* 1908), or decaying roses[1]—and moved in the years after 1920 to a linearity and clarity of expression best seen in his glamour photographs of the 1930s and 1940s. Ruben has moved in the opposite direction, first embracing the linear clarity of silver prints, then increasingly adopting the more arduous technique of platinum prints (with a more painterly tonal range), and most recently working with gum—one of the techniques favored early in Steichen's career but largely abandoned after about 1920 because of its technical rigors. The resulting images are indeed extraordinarily painterly, monotypes that defy replication and challenge our basic understanding of the photograph as a multiple. The more recent work is part of a larger return to photographic interest in painting, a medium whose utility twenty years ago photography was argued to have destroyed. According to New York dealer Laurence Miller, "We're back at Pictorialism, a recreation of what happened 90 years ago. Of course, it looks different. It's bigger."[2] In Ruben's case it isn't always physically bigger—although in some cases, such as her collage constructions printed in platinum, it is—but rather it is emotionally "bigger," with a subjectivity that goes beyond Steichen's pictorialist intentions of the 1910s. This is most obviously the case when we see Ruben herself turning to the subject matter of Rodin, whether seen in museum interiors, as in her *Aurora I* (1996) or *Illuminated Victor Hugo* (1997), both platinum prints, or out of doors in the Parisian light, as in *Burgher with Hand Down* (1996), printed on paper pulp. In her recent gum bichromate prints, as well as in her early gelatin silver nudes, Ruben has effectively bridged the divide between traditional formalist and postmodern photography.

Ruben's work is deeply imbued with a sense of the sculptural and of structures. This is not surprising given the artist's profound exposure early in life to the most sophisticated achievements in the visual arts. Born in Detroit, Michigan, and named for her maternal grandmother, Ernestine Krolik Kahn, an 1892 graduate of the University of Michigan, Ruben was the granddaughter of Albert Kahn, the German-born architect whose formal education ceased at age 11 but who

revolutionized industrial architecture in the twentieth century. Although we can find in Kahn's work the influence of such leading architects of the day as H. H. Richardson, Charles McKim, and Louis Sullivan, the larger Beaux Arts tradition was irrelevant to him compared to the influence of Detroit's emerging industrial history and purposes. The designer of two of the first assembly-line plants in the world—the Highland Park and Rouge plants commissioned by Henry Ford—and, later, of some 500 plants for Stalinist Russia, Kahn can be credited with profoundly changing the American and global built landscape. He became one of the most important figures in the creative scene in the American Midwest, equally known for his traditional, even derivative, designs in neoclassical or vernacular veins for individual clients (such as Edsel Ford, for whom he designed a Cotswold-inspired stone house in Grosse Pointe, Michigan) and for institutions (such as the University of Michigan, for whom he built most of the University's important earlier twentieth-century buildings such as the Graduate Library and Hill Auditorium). More to the point perhaps, Kahn's success as an architect allowed him to be an important figure in Detroit's artistic circles; indeed, he was to act as a principal player in the founding in 1919 of the Detroit Institute of Arts[3] and in the Detroit Arts and Crafts Society, whose first president also commissioned a house from Kahn.

While it may be difficult for us at the dawn of the twenty-first century to look at Kahn's industrial designs with fresh eyes, they were revolutionary in their day—enormous shed-like structures that simplified assembly, brought natural light into the workplace, and became emblems of the machine age. Kahn's industrial buildings—particularly those in Michigan—were objects of fascination for a generation of architects and artists including Le Corbusier, Mies van der Rohe, Charles Sheeler, Charles Demuth, and Frida Kahlo. Even before Kahn's death in 1942, his buildings were a unique source of inspiration to members of the Italian Futurist movement (see below)[4] and to painters such as Diego Rivera, who traveled to Detroit to paint a series of murals at the Detroit Institute of Arts that derived directly from his understanding of Kahn's revolutionary industrial work.

Kahn was, importantly, equally risk-taking in other ways. As his commercial success gave him the means to do so, he became an avid collector of what was then avant-garde European art; he became one of the earliest collectors of the works of the French Impressionists, including Claude Monet and Camille Pissarro, scrupulously making journal entries in his own hand that recorded every art acquisition he made from just after the turn of the twentieth century until he ceased to collect in the mid-1930s.[5] Most of these paintings were exhibited in Kahn's home in Detroit (designed by Kahn himself and now the home of the Detroit

3

4

5

4, 5 Collection installed in the Winston Malbin residence in Michigan, 1964
Courtesy of Ernestine Ruben

Urban League) and in his country home in what is now sub-urban Detroit. Although she was only 11 when Kahn died, Ruben remembers sitting with her stern grandfather in the Detroit house on Saturdays listening to the opera in the rather dark music room, surrounded by the light-filled land-scapes of France.[6]

Of equal note for Ruben's visual development is the fact that her grandfather's collecting began a family tradition. One of Kahn's children, and Ruben's mother, was Lydia Kahn Winston Malbin, who became one of the most important American collectors of early modernist art in the twentieth century. When she began to collect (in the early 1940s, after the death of her father), Mrs. Winston had the foresight to seek the guidance of such leaders as Alfred Stieglitz, the photographer and art dealer often credited with bringing Modernism to the United States, and Alfred Barr, founding director of the Museum of Modern Art in New York. Both were instrumental in revolutionizing collect-ing tastes, injecting a progressive sense of values that was incomprehensible to collectors of Albert Kahn's generation. Between the mid- and late 1940s—the period of Ruben's adolescence—Lydia Winston, with the support of her hus-band Harry, assembled a collection defined by an aesthetic sensibility open to the most advanced formal investigations. Among their purchases were works by Wassily Kandinsky, Paul Klee, Josef Albers, Piet Mondrian, Georges Braque, and Pablo Picasso. Most of Mrs. Winston's collection was marked by a taste for a certain linguistic absolute, as in Mondrian's *Composition in Black and White with Blue Square* (1935), a highly linear work in which color is more or less reduced. But Mrs. Winston's interests still allowed for the fantastic meanderings of the deep subconscious—as in Joan Miró's *Personage: The Fratellini Brothers* (1927), operating at the border of reality and dream. Both, perhaps, can be seen as expressing aerial flights from reality, albeit in different expressive vocabularies.

From about 1950 the Winston collection acquired a number of extraordinary works and fully committed itself to sculpture, including biomorphic forms by Hans Arp. In 1951 the Winstons met both Constantin Brancusi and Gino Severini in Paris, returning to the United States with the promise of a Brancusi—*La Negresse blonde (Blonde Negress)*—which was to arrive the following year. It had taken four or five visits to Brancusi's studio for Mrs. Winston to persuade the artist to part with the polished bronze version of the sculpture, a work of sublime formal purity; when they left with that promise, they also took with them a napkin on which the artist had drawn the base he wished them to make for his sculpture. The Brancusi—and Ruben's subse-quent studies in early Modernism as an art history student at the University of Michigan—left a legacy in Ruben's later work as a photographer, in the sculptural forms of the

human body to be found in her early silver and platinum nudes, such as *Teenage Arms* (1981). The Winston collection's first Severini—*Mare=Danzatrice* (1913–14)—gave birth to a true passion for Italian Futurism, then little known outside Italy. With the help of Benedetta Marinetta (wife of the founder of the Futurist movement), Mrs. Winston assembled a collection of Futurist art without parallel, and which included important works by Giacomo Balla and Umberto Boccioni, whose *Unique Forms of Continuity in Space* (1913) was one of the great (and now canonical) masterworks in the Winston collection (now in the Metropolitan). The Futurists exalted the cult of the modern, embracing the beauty of the machine and becoming the first avant-garde art movement to see art as action in reality. Mrs. Winston's embrace of the Futurists, perhaps in part due to her father's creative influence, was a particular mark of her willingness to take risks as a collector, to embrace new forms of visual expression. And to all of this Ruben was exposed throughout her adolescence and adult life.[7]

Ernestine Ruben was not herself to begin to make fine art photographs for another twenty years or more after the heyday of her parents' collecting activities, although art continued to play an important role in her life—first as a student of the history of art at the University of Michigan, then as a fine arts graduate student at Detroit's Wayne State University, and subsequently as a teacher. It is tempting to read into this postponement of vision another aspect of the Kahn-Winston family legacy—the overwhelming personalities of her grandfather and mother, and the power of visions that were not Ruben's own. Ruben's photographs combine a wide range of sources and influences, from the deeply personal to the canonically art historical, such as Edgar Degas's radical explorations of perspective in approaching the female nude in the 1890s.[8] She notes, of the path of her work, that "it started out as a simple expression of my creative needs….The path has reflected a certain awareness of the history of the nude in photography, a strong awareness of the history of art, of the different value systems between the United States and Europe, the influence of my family (in architecture, the use of space, and an emphasis on abstraction). It reflects my love for dance—strange poses defying reality—and music—its layers and rhythms."[9] Certainly the whirl of creative activity that surrounded her mother—who frequently played host to world-renowned artists, curators, and collectors at her home in Birmingham, Michigan—left another legacy for Ruben: an awareness of the tension between surface and substance, of the potential for disruption between the two, of a too easy reliance on surfaces, and thus of hypocrisy. Such issues are central to Ruben's work, which she sees as a struggle for authenticity— "I want to find myself in the middle of life's jungle."[10]

Ruben's earliest photographs of the body reveal simultaneous awarenesses, if not always influences: the memory of forms in space observed in Arp and Boccioni; and the knowledge of Margrethe Mather, Alfred Stieglitz, and Edward Weston's explorations of the female nude as sculptural objects seen in the lyrical mode. These images reveal a constant awareness of underlying structures, which the artist usually relates back to the structures of the human form, sometimes achieved through an emphasis on the contrast of positive and negative (*Zurich Invitation,* 1988) or through sculptural manipulations of light (*Side Neck,* 1981). When Ruben began to make photographs professionally in 1978, she did so as someone conscious of the meaning of her choices in both medium and subject matter. In her own words, "I consciously chose an art form that was not considered an art form, and a subject that was not accepted by anyone."[11] It is perhaps only a slight exaggeration to suggest that photography still held such a marginalized position in the late 1970s (although it was clearly seen in opposition to traditional media, such as painting, at that time), but it is certainly true that Ruben's particular interest in the body— an imperfect body, a body to whose flaws or particularities Ruben drew attention, rejecting the body-perfect vocabulary of earlier photographs of the nude such as those of Edward Weston—was unusual if not unique for its time.

Yet one of Ruben's greatest advances from the early 1980s and continuing into the 1990s was not only to draw our attention to the particular—the pimple on a man's buttock (*Palladium Pimple,* 1993) or the wrinkled skin of a twisting torso (*Big Chest,* 1993)—but to crop her images severely and to challenge us to see the part, rather than the whole. The effect is often one of semi-abstraction, in which it can take a moment to realize that we are looking at two extended necks aligning with one another (*Neck to Neck,* 1983), or the void below a man's armpit (*Fred on Tire,* 1983). This tendency allows us to situate even Ruben's early work firmly within the terms of postmodernism, where the thematization of fragment and totality shifts and we are encouraged to see the photograph as but an excerpt from a continuum.[12] The choice to articulate the fragment becomes a kind of necessity, albeit one that is made discretionarily. The fragment's purpose is to dramatize our lack of wholeness (either physically or psychically), not out of some obtuseness but because the enigmatic quality of the fragment casts doubt about whether the whole *can* be understood. In the hands of some, such as Robert Frank, the fragment was often manmade—a fragment of road, a telephone dial. For Ruben it first and foremost revolved around the human form, often depicted with enormous sensitivity and empathy, as in the depiction of soft and vulnerable fingers the artist called *Newborn* (1981).

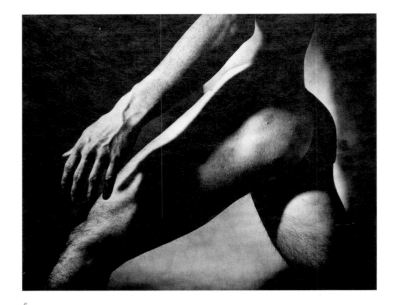

6

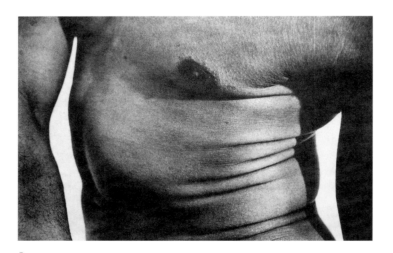

7

6 **Ernestine Ruben** *Palladium Pimple,* 1993, palladium on Japanese paper

7 **Ernestine Ruben** *Big Chest,* 1993, platinum print

8 **Ernestine Ruben** *Fred on Tire,* 1983, gelatin silver print

9 **Edgar Degas,** *After the Bath, Woman Drying Her Hair,* 1896
 silver print, The J. Paul Getty Museum, Los Angeles

10 **Ernestine Ruben** *Crazy Triangles,* 1983, gelatin silver print

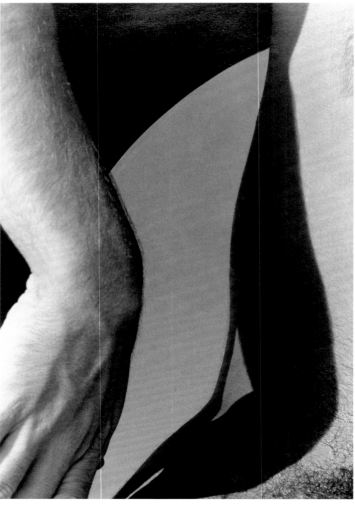

8

For Ruben, the choice to focus on the human form mediated between the postmodernist fragment and a more emotional totality. As she has put it, the choice to work with the body was both necessary and inevitable "because of human touch, being in touch with my own humanness, in touch with life....There is mystery in lack of specificity, and no specific emotion...not just love, not just wonder, not just beauty, but all the qualities attributed to having life as a human." [13] Ruben's interest in the human body is the single greatest informant of her art, and moves well beyond her photography to inform every aspect of her practical and creative life: "Our garden is designed around contours of the human body, some of our furniture has been inspired by these forms—even our kitchen architecture reflects the roundness of the human body. As I grow older, the work assumes some of the aspects of the aging process." [14] From her earliest work in the late 1970s, Ruben's photographs bear the marks of a subject matter and an approach that have human significance, and as such form part of what has been termed a "rehumanization" of the photograph. [15] Even when the works bear the hallmarks of the postmodern fragment, they also reveal an empathetic connection on the part of the artist, one confirmed by her tendency to entwine herself with the bodies of her models in photographing them (*Crazy Triangles,* 1983).

While Ruben argues that her subject matter is the true motivation for her work, it is through her choice and manipulation of media that she achieves her most significant effects. Indeed, her choices of subject are often traditional and fall into three general categories—the nude, the landscape, and the body (both human and sculptural) in the landscape. Certainly her choices are weighted with meaning. For Ruben, the choice to strip the human form of clothing is the equivalent of stripping it of (or denying it) hypocrisy. [16] She seeks to find truer expression of life in the language of the body itself, although this notion of truth is both highly subjective (as I shall discuss below) and highly changeable, particularly when Ruben represents the body in motion where its relationship to space is itself constantly in flux. Equally, her approach to the landscape is weighted but multiple: she alternately finds faces in the landscape, as in *HSR's Eyes* (1988), or landscapes that resemble or contain the qualities of the human form, as in *Human Heap* (1983), *Hand Bush* (1988), or *Hooded Creature* (1990), a photograph from Ruben's memory-laden work in the Jewish cemetery in Prague, a part of the artist's recovery of her own Semitic heritage. Other landscapes by Ruben, particularly from the 1990s, have a greater degree of purity, without referencing such physical and corporeal relationships, but even here they are frequently referential: the "pure" landscape often invokes moods, such as Ruben's photographs from the Charente region of France (1995) in which a kind

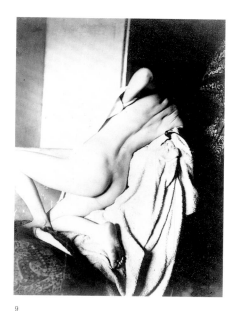

9

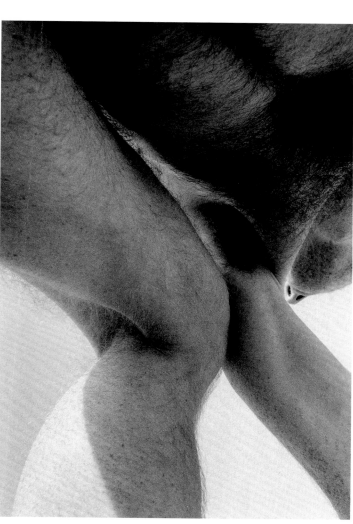

10

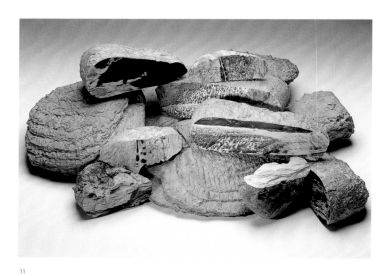

11

11 **Ernestine Ruben** and **Jan Cincera,** *Petra Sculptures,* 1997,
paper pulp and platinum and silver photographs

12 **Ernestine Ruben** and **Jan Cincera,** *The Petra Project,* 1997,
partial installation view from the Czech Embassy, Washington, D.C.

13 **Ernestine Ruben** *Heinz Bent to Right,* 1998, gum bichromate print

14 **Ernestine Ruben** *Diane in Whirl,* 1998, gum bichromate print

15 **Ernestine Ruben** *Quiet Lean,* 2000, gum bichromate print

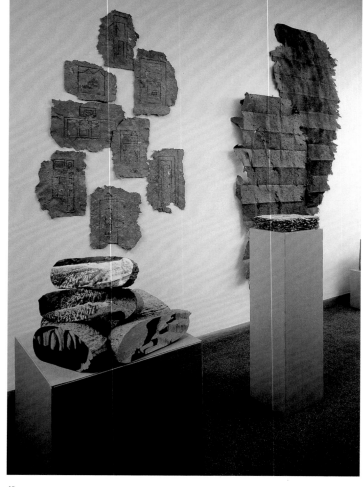

12

13

14

15

of classical calm descends on the landscape, or her work in Yosemite of the following year, such as *Big Cave* (1996). We are far from the response of Group ƒ/64 to Yosemite, in which light effects are depicted with startling clarity. Ruben's light effects in Yosemite are moody, evocative, dreamlike, and even menacing. Ruben's work in the ancient Jordanian city of Petra reinjects the human form into the landscape and reflects (or even seeks) the progression of the phases of human life, from *Birth* (1997) to *Vertical Old Age* (1997), where the artist establishes a deeply personal relationship with her environment, reflecting her own growing awareness of mortality. Ruben's interest in the body in the landscape is an intermediate zone, revealing waves of ambiguous life from the animal to the vegetal. This intermediate zone has been a preoccupation for Ruben during the late 1990s, from images of a dreamlike, or even surrealist, vision such as *Diane in Whirl* (1998) or *Heinz Bent to Right* (1998)—where the effects are achieved through manipulation in either the shooting or the printing process—to those of a more contemplative quality, again invoking moods, such as Ruben's recent work in Africa, including *Quiet Lean* (2000). These last three images suggest something of the remarkable variety of emotional effects Ruben is able to achieve through the gum bichromate process.

Ruben captures many of her most striking effects through a manipulation of her media. This manipulation of the medium—particularly in Ruben's gum bichromate prints—is central to the work. The gum bichromate process allows the artist to manipulate such effects as tonal contrast and color saturation during the printing process itself,

enabling her to achieve often otherworldly, painterly effects. Ruben argues that it is this very manipulation, in fact, that gives her work its authenticity. Like the choice to approach the body in uncanonical ways, Ruben employs processes, techniques, and materials that are not part of—or at least had fallen out of—the canon of modern photography. In this way, Ruben says, "I con my way out of the prison cell" of the two-dimensional and strictly representational.[17] Such manipulation of medium and process is also in keeping with the approaches of postmodernism. Indeed, a number of younger artists—Adam Fuss, Joseph Nechvatal, James Welling—have turned to formerly outmoded media akin to gum bichromate, such as the photogram, because of their interest in the interaction among light, chemicals, and paper.[18] The final image is not an end in itself, but the record of the process by which it was created. These photographs depart from the modernist image in part because they are so clearly the product of manipulation, a manipulation that does not allow us to believe in the images as an unmediated record of reality. Such manipulation typically has a distancing effect for the viewer, making it harder to imagine ourselves in the photograph or to implicate ourselves in the action at hand. This is indeed the case for photographs by Ruben such as *Claudia in Flurry* (1998) or even a platinum print such as *Rome/Statue in Middle* (1996), where the antique relic at the center has a surreal clarity that distances us from more than a dreamlike participation. Color in Ruben's gum bichromate work can alternately either engage or distance, but it is always highly personal, as is typical of the intensely personal and malleable quality of the medium.[19]

16

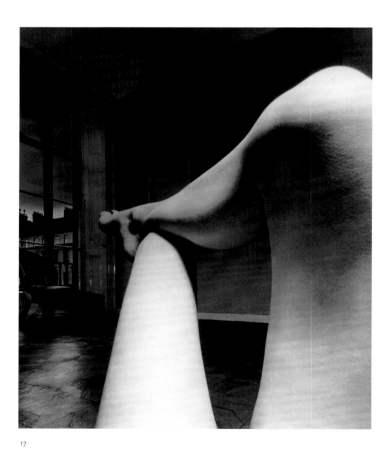

17

In the hands of other artists, this interest in manipulation has often taken the form of at least a partial fictionalization. For these artists—Americans such as Cindy Sherman, Neil Winokur, or again Adam Fuss (who may all be looking back to Bill Brandt's staged scenarios of London life in the 1930s), or European artists such as Thomas Struth—the interest may be primarily in creating a heightened sense of intensity. Yet as some observers, such as San Francisco photography dealer Jeffrey Fraenkel, argue, the distance between those who stage and those who manipulate or move beyond the documentary in other ways, such as Ruben, is not as great as it seems.[20]

Ruben has suggested that the medium of photography itself suggests the possibility of manipulation: "Why photography? Because I can select from both outside and inside those elements that make 'my world.' I can change and create and develop life into my own reality."[21] This manipulation informs the very choice of medium, but also extends to the viewer, whose perceptions of reality are equally subjective. Ruben's comments about her work underscore the extent to which she recognizes their subjectivity. She has observed, "…what is the real content? That's up to every individual viewer. For me, my suitcase is pretty packed with content ready for whatever comes. I come to the process wanting to examine life and death and their relationship to each other—in the specific language of photography, which is about emerging from dark to life, trying to maintain the three-dimensional presence of 'real' life, which defies a piece of paper."[22] Some have called this movement in which Ruben's work can be situated a "New Subjectivity," playing off the *Neue Sachlichkeit,* or New Objectivity, movement of the 1920s. Ruben candidly acknowledges that she achieves such subjectivity through the manipulation of process, something that hinges equally on her own subjectivity and that of the viewer: "For me, art is all about process—not technique, but process. It is about the discovery of life, or energy. It is the long (or short) trip we take to engage our senses, about feeling fulfilled, touched, stimulated. It is about coming alive…. In my best work, there is a spark that can be made of almost anything, depending on the viewer. For me, it is what the camera offers, not in a dogmatic way, but in a suggestive way. Then, when the work is good, there's a dialogue between what's out there in the camera and what's inside me."[23]

Ruben's recent work with gum bichromate and printing on paper pulp can also be seen as part of the so-called "anti-minimalist" movement, part of a postmodernist desire to destroy or "deconstruct" the distinctions between objectivity and subjectivity, between formalism and realism.[24] This is a movement that denies pure rationality, pure objectivity, in favor of a more complex kind of dream world that contains both the representational and the personal,

16 **Edward Weston** *Nude,* 1927, gelatin silver print
 University of Michigan Museum of Art, Gift of Two Friends of the Museum

17 **Bill Brandt** *August 1951 (Belgravia, London, 1951),* 1951, silver print
 © Bill Brandt / Bill Brandt Archive Ltd.

18 **Ernestine Ruben** *Upside Down,* 1981, platinum print

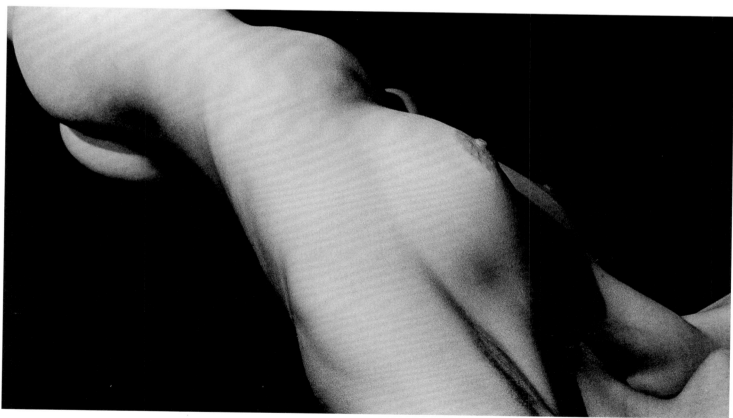

18

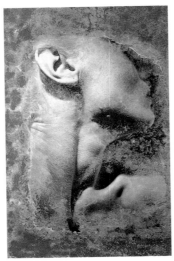

19

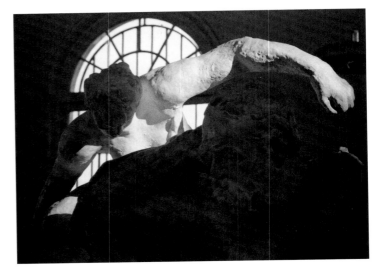

20

76

the rational and the irrational. In Ruben's work the complex layers achieved both through the use of paper pulp, drawing attention to the materials themselves, and the gum bichromate process have a certain baroque quality—whether in a work such as *Dancer's Jaw* (1987), where the image emerges from the paper in a way that draws attention to itself, or *The Cry with Patina* (1997), where the paper pulp adds an additional layer of intensity to the emotional content of Rodin's sculpture and the dramatic angle and cropping.[25] The works printed on paper pulp in turn connect the artist's concern for appropriation and for skin with concerns for layering (and the layers of reality) and emergence, often finding parallels between form and content in her most movement-filled images.

Another central tenet of postmodernist theory and photography is that the work of art achieves meaning not through its relationship to what is represented but in relation to other representations. One of the central theorists of postmodern photography, Douglas Crimp, has argued in conjunction with artists working in this mode that "representation has returned in their work not in the familiar guise of realism, which seeks to resemble a prior existence, but as an autonomous function that might be described as 'representation as such.'"[26] Here, too, Ruben's work finds resonance because it doesn't so much invoke an external reality as one that exists in the history of photography itself, in the pictorialist sculptures of Steichen, in the lyrical nudes of Edward Weston, or in the sculptural nudes of Bill Brandt (*August,* 1951). Although outwardly less radical than the early works of Sherrie Levine, who cut pictures from fashion mag-

azines into the silhouettes of Washington, Lincoln, and Kennedy, Ruben's work frequently invokes images that are already a part of our international cultural mythology, as in the sculptures of Rodin, known both in themselves and in Steichen's iconic photographs of them (*Rodin,* 1901). Here, the concept of appropriation—discussed by writers including Crimp and Abigail Solomon-Godeau—is literal.[27] Ruben's photographs (such as *The Arm of the Muse,* 1994) re-present the work of the nineteenth-century sculptor and consciously insert themselves into the political discourse of the museum, since many of Rodin's statues are literally seen within the context of the museum, historically an institution of academic categories.

Likewise, we can see a relationship with Levine's later project of rephotographing, unaltered, images by recognized fine art photographers such as Edward Weston and showing them as her own work.[28] But Ruben more subtly—and less subversively—draws attention to the layers of history and cultural mythmaking, invoking the cultural and psychological resonance of these images through strategies that are perhaps more visually complex than Levine's. Ruben's quotations from Weston or Rodin (or Steichen, himself loosely quoting Rodin) are less subversion and more refractive lens of historicized visual pleasure. The same kind of device in Ruben's work becomes self-referential in certain photographs that involve the overlay of images, such as *Hand Bush* or *HSR's Eyes* (both 1988), a kind of biomorphic superimposition on the landscape.

While postmodernist theory and photography were originally thought to locate the individual—either as photog-

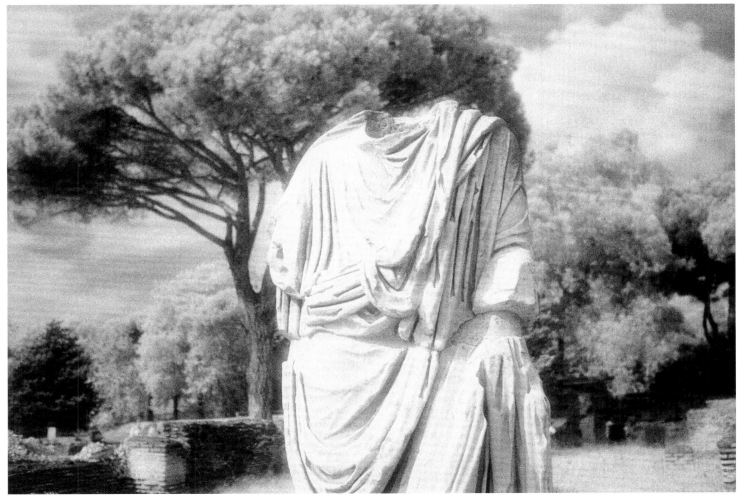

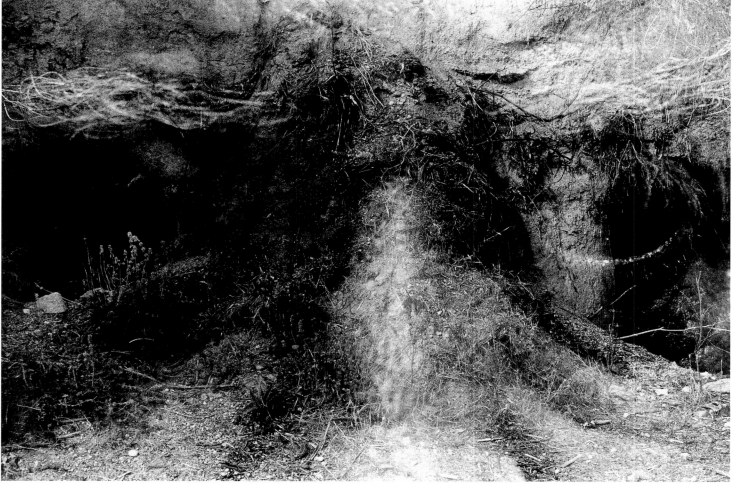

rapher/maker or viewer—in a situation of powerlessness, the various postmodern strategies Ernestine Ruben employs have more complicated effects. In reinserting her work within the history of the photographic image, both within and outside of the political discourse of the museum, Ruben empowers her viewer, avoiding the oppressive stance of the postmodern purist both on the plane of representation and that of everyday life. It is the layering of her visual strategies—frequently employed with remarkable balance, achieving effects that are complex and yet pleasing to the eye—that overcomes the inward-looking practice of much contemporary photography. Her fragments and manipulations—both formal and technical—are self-aware but not self-conscious; they deny neither lived experience nor visual pleasure. They take risks, but of a subtle variety that does not draw attention to itself. Ruben's work provides a bridge between the great classic and formalist traditions forged by the likes of Alfred Stieglitz, Edward Steichen, and Edward Weston, to which she is heir, and the postmodernist work of Cindy Sherman, which is perceived as belonging to the world of painting and sculpture.[29] They contain the memory of the traditions of painting and sculpture as well as of photography's artistic traditions. As such, Ruben's images inscribe themselves as amongst the most powerful—and possibly the most enduring—works of late twentieth-century photography.

Notes

1 For more on Steichen's early work, including his work with Rodin, see Joel Smith, *Edward Steichen: The Early Years* (Princeton: Princeton University Press & the Metropolitan Museum of Art, 1999).

2 Quoted in Pepe Karmel, "Out of the Ghetto?" *ARTnews,* Vol. 93, No. 4 (April 1994), p. 147.

3 See William H. Peck, *The Detroit Institute of Arts: A Brief History* (Detroit: Wayne State University Press, 1991), pp. 57–59 for Kahn's role as one of the initial members of the Arts Commission and for his influence on the selection of Paul Cret as architect of the first DIA building.

4 Reyner Banham, *Theory and Design in the First Machine Age* (London: Architectural Press, 1960), p. 100.

5 This detail was relayed to me in conversation in March 2000 by Albert Kahn's last surviving daughter, Mrs. Rosalie Butzel. Mrs. Butzel died in late 2000, and I have been unable to consult the surviving ledgers of Kahn's collecting activities.

6 Conversation with the artist, March 2000.

7 The Winston Malbin Collection was frequently exhibited (and published) throughout the 1950s and well into the 1970s. See, for example, *20th-Century Painting and Sculpture from The Collection of Mr. and Mrs. Harry Lewis Winston* (Ann Arbor: University of Michigan Museum of Art, 1955); *Selections from The Lydia and Harry Lewis Winston Collection (Dr. and Mrs. Barnett Malbin)* (Detroit: Detroit Institute of Arts, 1972); and *Masters of Modern Sculpture: The Lydia and Harry Lewis Winston Collection (Dr. and Mrs. Barnett Malbin) and the Guggenheim Museum Collection* (New York: Solomon R. Guggenheim Museum, 1974). Pieces from the collection were donated to a number of institutions, including the Metropolitan Museum of Art, the Detroit Institute of Arts, and the University of Michigan Museum of Art; the balance of the collection was dispersed to members of the family after Mrs. Winston Malbin's death, or sold at auction (Sotheby's New York, May 16, 1990). Papers relating to the collection were given to Yale University.

8 For a detailed investigation of Degas's work with the camera, see Elizabeth C. Childs, "Habits of the Eye: Degas, Photography, and Modes of Vision," in Dorothy Kosinski, *The Artist and the Camera: Degas to Picasso* (Dallas: Dallas Museum of Art, 1999), pp. 70–87.

9 Conversation with the artist, July 2000.

10 Conversation with the artist, March 2000.

11 Conversation with the artist, March 2000.

12 For a fuller discussion of this aspect of postmodernist photography, see Ian Jeffrey, "Fragment and Totality in Photography," *History of Photography,* Vol. 16, No. 4 (Winter 1992), pp. 351–357.

13 Conversation with the artist, July 2000.

14 Conversation with the artist, July 2000.

15 Gene Thornton, "Post-Modern Photography: It doesn't look 'modern' at all," *ARTnews,* Vol. 78, No. 4 (April 1979), pp. 64-68.

16 For a rather stylized discussion of the various meanings of the nude in contemporary photography, see Lynne Tillman, "Nude Notes," *Art on Paper,* Vol. 3, No. 3 (January–February 1999), pp. 29–31.

17 Conversation with the artist, March 2000.

18 The adoption of alternative processes, including gum bichromate, by a wide variety of contemporary photographers is discussed in "Alternative Processes: A Contemporary Revival," in *The Alternative Image: An Aesthetic and Technical Exploration of Nonconventional Photographic Printing Processes* (Sheboygan, Wisconsin: John Michael Kohler Arts Center, 1983).

19 For a discussion of the role of color in gum bichromate printing and of other artists working with this technique, see Joan Harrison, "Colour in the Gum-Bichromate Process: A Uniquely Personal Aesthetic," *History of Photography,* Vol. 17, No. 4 (Winter 1993), pp. 369–376.

20 Quoted in Karmel (note 2), p. 148.

21 Conversation with the artist, July 2000.

22 Conversation with the artist, March 2000.

23 Conversation with the artist, March 2000.

24 On these issues, and the postmodern/poststructuralist writings of Douglas Crimp, see Michael Starenko, "What's an Artist To Do? A Short History of Postmodernism and Photography," *Afterimage,* Vol. 10, No. 6 (January 1983), pp. 4–5.

25 For insights into Rodin's own interest in photography, and its possible impact on his sculptural achievement, see Jane R. Becker, "Auguste Rodin and Photography: Extending the Sculptural Idiom," in Kosinski (note 8), pp. 88–115.

26 Douglas Crimp, "Pictures," catalogue essay for exhibition, published by the Committee for the Visual Arts, 1977, p. 3.

27 See Douglas Crimp, "Appropriating Appropriation," in *Image Scavengers* (Philadelphia: Institute of Contemporary Art, 1982), pp. 27 ff. and Abigail Solomon-Godeau, "Playing in the Fields of the Images," *Afterimage,* Vol. 10, Nos. 1 & 2 (Summer 1982), pp. 11 ff.

28 For an interesting survey of postmodernist photography by young photographers in the late 1970s, such as Levine and Cindy Sherman, and critical responses to it, see Linda André, "The Politics of Postmodern Photography," *The Minnesota Review* n.s. 23 (Fall 1984), pp. 17–35.

29 For a fuller discussion of this divide in contemporary photography, and the current potential for "détente," see "Photography's Great Divide" [an interview with Museum of Modern Art Curator of Photography Peter Galassi], *ARTnews,* Vol. 98, No. 2 (February 1999), pp. 86–89.

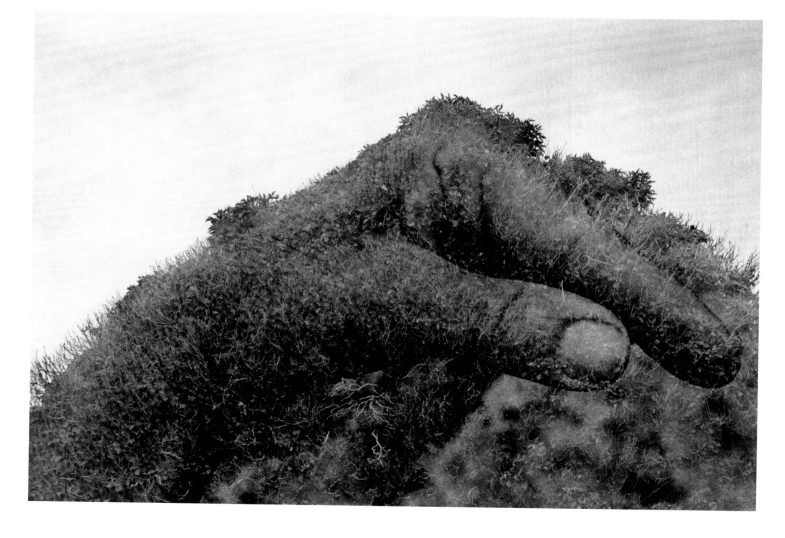

plate 35

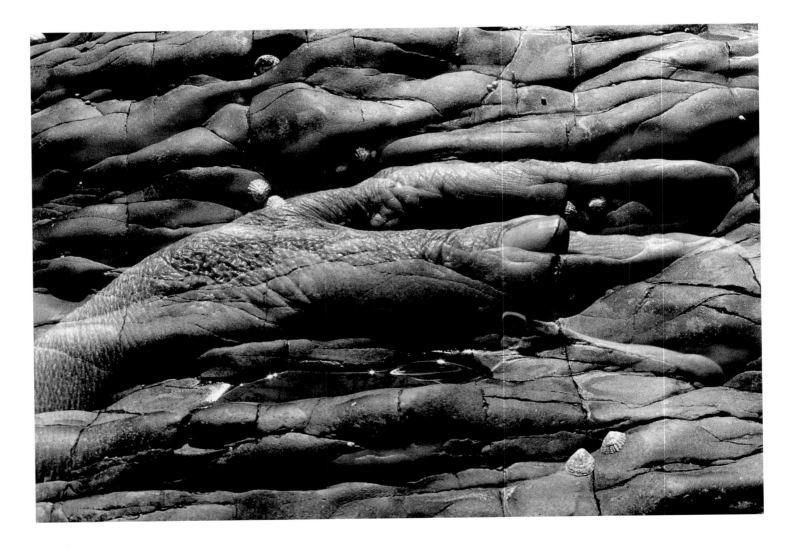

plate 36

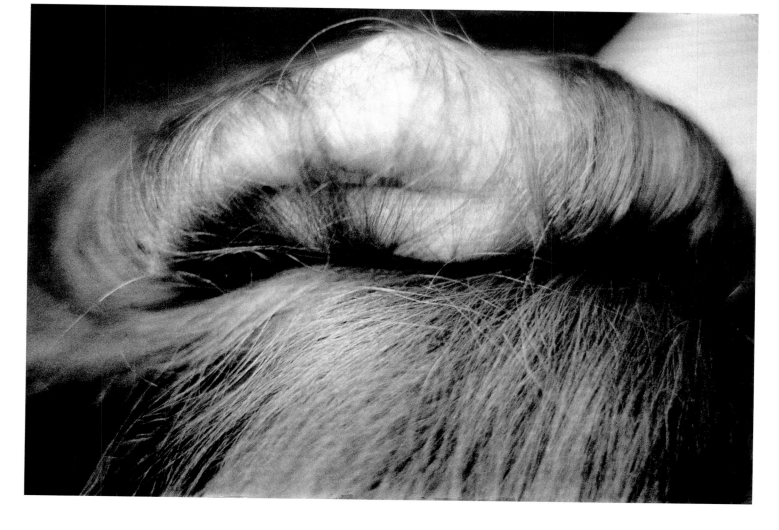

plate 37

plate 38

plate 39

plate 40

plate 41

plate 42

plate 43

plate 44

plate 45

plate 46

plate 47

plate 48

plate 49

plate 50

plate 51

plate 52

plate 53

plate 54

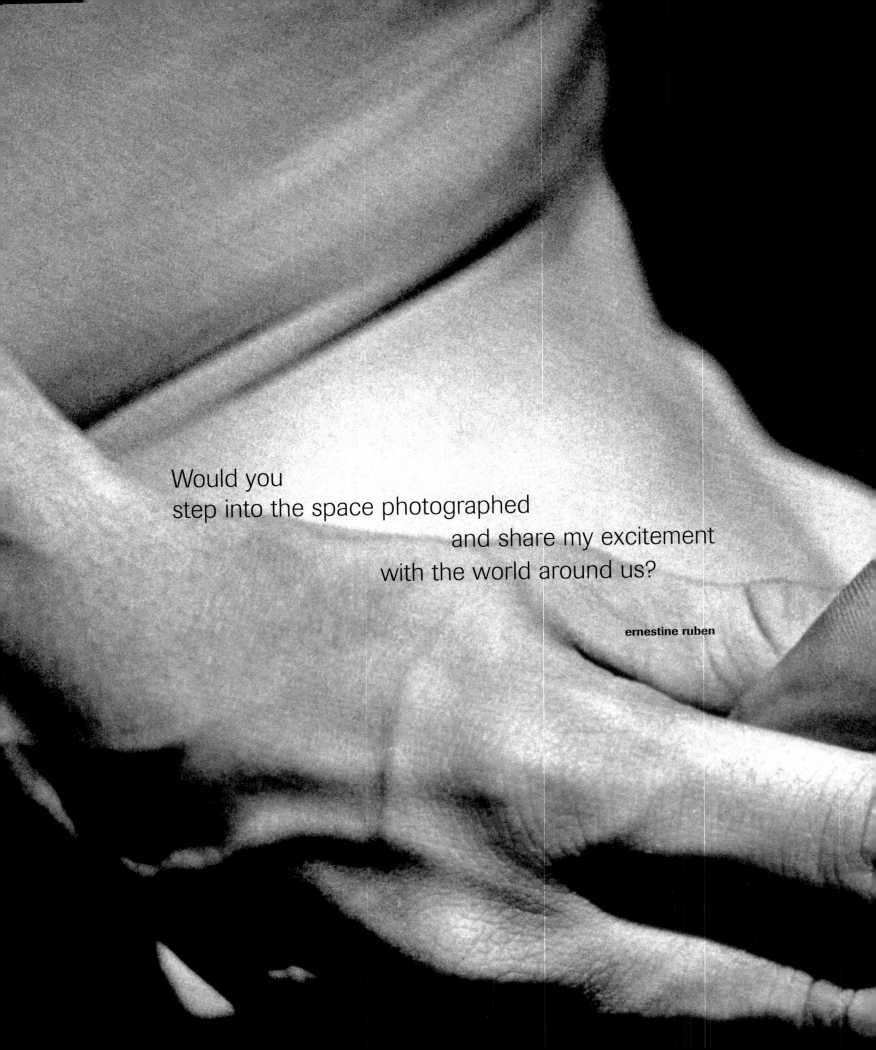

Would you
step into the space photographed
 and share my excitement
 with the world around us?

ernestine ruben

the body
and the silver skin

lyle rexer

"…all that one can do is to produce a definitely self-contained surface which is in no part accidental, a surface which, like natural objects, is surrounded by the atmosphere from which it receives its shadows and its lights, simply this surface, nothing else."
Rainer Maria Rilke, *The Rodin Book* [1]

I take it as axiomatic that in photography the appearance of the body is a sign of its absence, of a desire for that which is unavailable. What is the nature of that absence? What is the character of that desire? In these photographs by Ernestine Ruben the absence includes everything that cannot inhabit a silver image: thoughts, feelings, the mute companionship of things. The desire they express is for pure habitation, for a work whose surface is continuous with the world, for contact uncontaminated by memory and unmediated by representation. If the original impulse of photography was to divide and capture time (I am not sure it was: what about the arranged still life?), then the medium was always negative, an index of lostness. And the more time passes for any photograph, the greater the index value, the distance from the real, becomes. When I look at the bodies in Ernestine Ruben's most outrageous photographs, I see the body of photography struggling with its lack of materiality, its belatedness, its thin destiny as mere sign.

Ernestine Ruben began making art by sculpting. This original impulse is significant but also somewhat misleading. It is the opposite of Michelangelo's struggle, where three-dimensional form emerges out of inchoate material continuity, on its journey toward pure idea. Ernestine Ruben wants to peel back the skin of the photograph, expose it so it can come into being and into contact with us. A photograph is all form, all "idea," from the outset, and Ruben wants it to become material, to participate in a progress toward ecstasy and dissolution. Paradoxically, she seems to believe in the power of photography to rematerialize the abstractions of Arp, Brancusi, and Boccioni, to set them in motion and drag them out of eternity and into time. No wonder skin is so important in these photographs.

Ruben's photographic telos runs counter to several contemporary visual trends in which the body figures prominently. The first is, broadly speaking, an erotic aesthetic, in which the loss of the represented object is accepted as the ground of desire, fantasy, and identification. Form, texture, depth, and other elements of so-called composition contribute analogically to the image; that is, we read and translate them from the two-dimensional tableau into the two-dimensional theater of the mind. No matter what recuperative terms are assigned to this experience, whether "beauty," "aesthetic pleasure," or "style," it cannot be separated from the voyeuristic and pornographic. The relationship of the image to the actual body is "quotational," in the phrase of critic John Berger. Ruben has absorbed all the versions of this relationship, from the late nineteenth century through Stieglitz and Weston, to Brassai, Ralph Gibson, and Eikoh Hosoe. She is happy to exploit the fantasies engendered by the photographic image, which again depend on the absence of things seen,

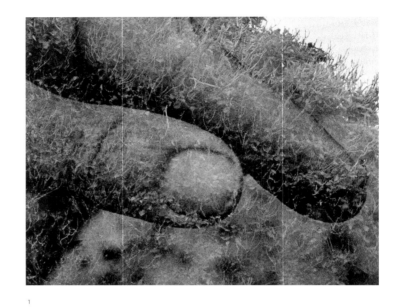

1

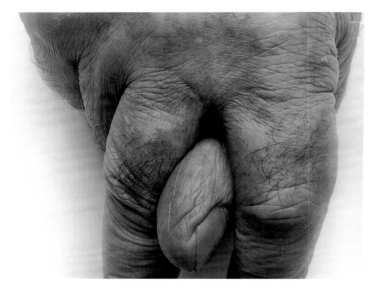

2

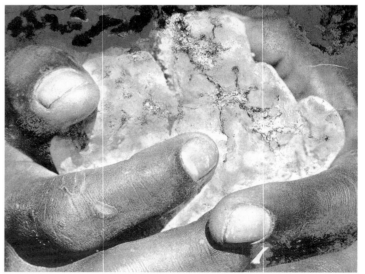

3

but she is not content to leave it at that. As she once wrote, "Would you step into the space photographed and share my excitement with the world around us?" [2] We would if we could.

Nor is Ruben interested in textualizing the body—perhaps the dominant trend in contemporary representation. Ruben experiments with fragmenting the nude, focusing on parts, playing with metonymy. A similar strategy is common to a host of artworks that depict the body as the site of cultural conflict and sexual ambiguity. From Bruce Nauman and John Coplans through Annette Messager, Cindy Sherman, and David Wojnarowicz, fragmentation of the body's image signals the erosion of the concept of a discrete "self." It points further to a corporeal politics of image, gender, and socially constructed identity. The spiritual innerness attributed to the human form at least since the Renaissance has largely vanished under the camera's historicizing scrutiny.

Of course, the body is always a text. It always has a socially constructed meaning in any representation, but the body is transparently available to artists only when assumptions about it are shared, as they cannot be today. Whose body is it, anyway? This question provokes a host of melancholy and generally affectless answers. Thomas Ruff and Rineke Dijkestra, to take just two examples, respond with an inventory of color portraits in which all the marks of individuality are there, but the expressiveness that might solicit our engagement is rigorously expunged. Their subjects remain stubbornly unappropriated and therefore, perhaps, free. In any case, they are insistent in their anonymity.

Ruben tables the question of identity and politics because, for her, there is something more fundamental to be known. If sculpture is relevant as more than just a visual referent, it is the anti-idealist sculpture of Rodin, a sculpture of desire with a skin, so to speak. Like Edward Steichen a century ago, Ruben reveres Rodin, whose vision of the body was uncanonical, to say the least. The poet Rainer Maria Rilke once wrote of Rodin that "a piece of arm and a leg and a body is for him a whole, a unity." [3] Ruben's photographs aspire to this plenitude. Her nudes are entangled. Skin is poked, pinched, and stretched. Torsos are touched and explored, even as they thrust forward to meet that touch, twist, and turn. In a sense, Ruben makes no distinction between a living body and a piece of sculpture, say an Indian erotic carving, because they share a fullness that exceeds representation. Her images manage to achieve a dynamic relation with the viewer. They both extend into our space and draw us into the hidden hollows and discoveries of the body. The more you look at these nudes, the more palpably you feel the skin of the photograph being stretched. Even Ruben's surrealist forays—*Hand Bush* (1988), for exam-

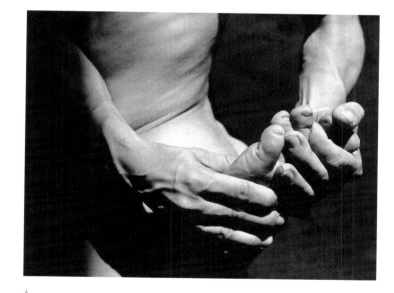

117

4

1 **Ernestine Ruben** *Hand Bush,* (detail), 1988, gelatin silver print

2 **John Coplans** *Self-Portrait (Thumb and Fingers, II),* 1999, silver print
Courtesy Andrea Rosen Gallery, New York, © John Coplans

3 **Ernestine Ruben** *Hands with White Rock,* 1998, platinum print on paper pulp

4 **Ernestine Ruben** *Cradle of Toes,* 1987, gelatin silver print

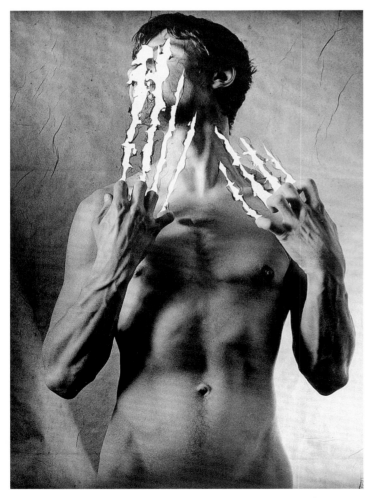

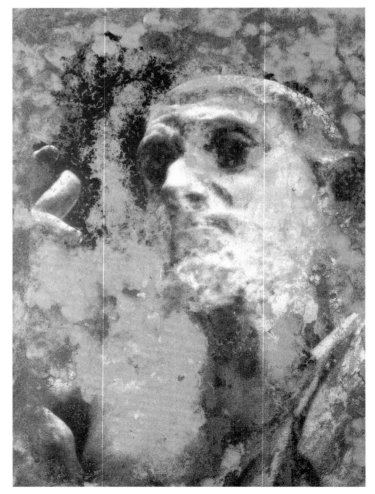

5

6

5 Michal Mackü *Gellage 7*, 1989,
 silver gelatin emulsion collage
 Michal Mackü is represented
 by the John Stevenson Gallery,
 New York.

6 Ernestine Ruben *St. John from Burghers
 of Calais*, 1997, platinum print on paper pulp

7 Ernestine Ruben *Hand on Breast*, 1998,
 gelatin silver print on paper pulp

8 Ernestine Ruben *Jaime's Fist under Chin*,
 1987, gelatin silver print

9 Ernestine Ruben *Hand Shadows*, 1999,
 iris print

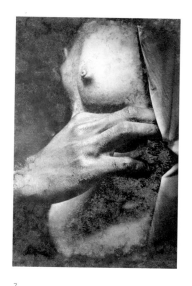

7

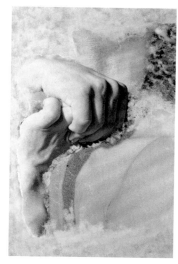

8

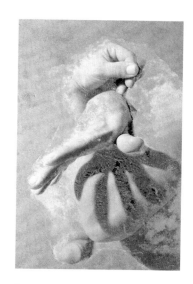

9

ple—are not primarily visual but tactile. Tiny trees grow out of a hand, summoning an impossible sensation, quite apart from whatever symbolic associations the image evokes.

Ruben's recent images on handmade paper make explicit her straining against photography as conventionally defined. In these images, parts of bodies literally emerge or tear their way through the image surface, which is heavily textured from the vegetable material of the paper. The body as image attempts to trespass the barrier of the photographic surface, to become something present to the viewer. Superficially, the approach resembles that of Czech photographer Michal Mackü, who peels the image-bearing emulsion off his negatives, then replants it, much distorted, on another surface. Mackü's startling nudes, some splintering into pieces, some pulling themselves in two, make representation, not expression, the issue.

If all your impulses are three-dimensional, and you grew up in a house containing examples of sculpture by Brancusi and Arp, as Ruben did, why not simply make three-dimensional work? Why content yourself with recording two dimensions in the real world if it makes you so impatient? What drew Ruben to the photograph, it seems to me, was its abstracting power, its ability to direct a viewer's attention and to restrict experience as sculpture cannot. For Ruben, the photograph has a focus and an instant symbolic concentration. But, it goes without saying, this is accomplished with the hand as much as the eye. Photography teacher Nathan Lyons brought this home to her in a workshop she took with him in France. Since the 1960s, Lyons has been an advocate for the use of all the available techniques of photography, including so-called alternative processes.

Ruben has always been restlessly experimental, printing photos on paper, fabric, and plastic, creating mechanized photographs and photo sculpture, not to mention collaborative installations with paper artists and architects. Her impulse to "free the photograph from the wall," as she puts it, led her to James Luciana, who introduced her to several non-silver processes and nourished her reconsideration of the photographic surface. She then worked closely with Paul Wong at Dieu Donné in New York to create paper that would enable her to achieve sculptural images using these techniques. More recently, she has been printing with gum bichromate, a layering technique invented in the 1850s and brought to perfection a century ago by Robert Demachy, Edward Steichen, and the Photo-Secession. Ruben has taken workshops in the technique with one of its contemporary masters, Sarah Van Keuren. As Ruben remarked in a recent conversation, "I left simple silver and platinum for moveable, physical skins of paper and gum, to introduce sensuality to the photo object that I already developed in the subject."[4]

Ruben is not alone in her impatience with the limitations of the silver surface. Nor is she singular in looking to antique photo processes to recover the "objectness" of the photograph. She is, de facto, a member of what I have called the antiquarian avant-garde.[5] So broad is the movement to return to old photo processes and so mixed are its motives that it might not be credited a movement at all. Almost every photographer who still enters a darkroom inevitably

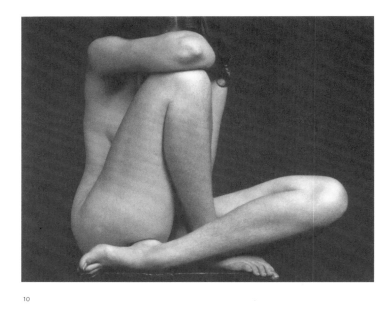

strays into alternative processes, even if only briefly. This work embodies approaches to photography very different from those of artists such as Dijkestra or Cindy Sherman, whose career has consisted largely of photographing herself in pop cultural and art historical tableaux. It nevertheless arises from the same cultural circumstances, the same artistic world. The antiquarian avant-garde is a response to conditions undermining traditional photographic practice and the idea of the photographic object, not to mention the photographic art object.

Like the computer industry today, photography in the nineteenth and early twentieth centuries moved inexorably from proliferation toward a standardized set of processes and specifications, as well as a common, consistent repertoire of effects, based almost exclusively on silver halide chemistry. There are many variations of silver, of course, but once wet collodion negatives on glass plates gave way to celluloid-based roll film and the albumen (egg white) coated print gave way to a print coated with an emulsion of gelatin and silver, the tone values, physical and visual stability, and "look" of the modern photograph were established. Nearly every other photographic practice was obsolete and every other photographic "look" came to seem antiquated, unreal, specialized, or "impure." Edward Steichen and the Photo-Secession eventually abandoned painterly pictorialism and with it alternative techniques such as gum printing and the autochrome, an early color process, in favor of silver's clarity and neutrality. The Group $f/64$, loosely formed in the 1930s and including Ansel Adams and Edward Weston, enshrined that aesthetic. "The simple dignity of the glossy print," is how Adams defined the group's aesthetic commitment.[6]

By the middle of the 1960s, photography had become the dominant image-producing modality in the world. Leading universities such as Yale had organized photography programs, important galleries in New York and Paris exhibited photography exclusively, and an active department of photography at the Museum of Modern Art was long established as the premier center for the collecting and exhibition of work. The canon of art photographers— camera artists—was being codified in the pages of *Aperture* and other photo magazines, and the aesthetics of photography as a distinct complex of values and assumptions had developed along the lines of painting and sculpture, with orthodoxies and schools, center and fringe. Beaumont Newhall's influential history bestowed a formal trajectory on what otherwise appeared as a tangle of usages, events, and ontological uncertainties.[7] There was, after all, something called photography, a distinct art owing nothing, finally, to painting and its various "isms," liberated as well from its industrial siblings—advertising, journalism, documentation of all sorts—and progressing into new territory according

to its own doctrines. These doctrines had to do with composition, tone values, form, style, mastery, expressiveness, and vision. They were flexible enough to include the highly abstract Bauhaus practices of Laszlo Moholy-Nagy and the street photography of Robert Frank, although the latter not without considerable initial resistance. But they did not include techniques that revised the role of the camera, promoted intervention with the image after the fact, or allowed materials an intrusive presence. Nor did the dominant sense of photography admit the possibility of violating the photograph's surface. Like the canvas in painting, the optical surface of the print guaranteed the art object's unity and integrity.

And then, like a bad dream, photography lost this hard-earned identity. It was stripped of its self-styled artistic autonomy. In the mid-1950s, Robert Rauschenberg began to incorporate disparate found materials into the plane of his paintings. Almost incidentally, some of that found material was photographic. He called these assemblages combine paintings. Over the next two decades, photographic imagery would come to act a major role in the cultural and visual drama taking place in the field of these paintings and throughout the fine arts generally. Like rabble admitted to the palace for one day of the year, the ordinary, anonymous, reproducible imagery of journalism and the mass media entered the mythic territory of original, expressive gesture. And once admitted, it was impossible to dismiss. The rabble declared that the heroism of painting (explicitly De Kooning's and Pollock's), with its martyrs, legends, and museum-temples, no longer corresponded to the nature of things, if it ever had. Likewise, the conception of the expressive gesture (and the artwork) as the bearer of unique and difficult meanings, embodying the soul and vision of an individual creator, was a thing of the past. Nor was art an autonomous object but rather an unprivileged form of data—or "information," as artist Joseph Kosuth called it—crowded by signs and meanings from an increasingly image- and commodity-choked world. The artist was not a creator but an organizer, *bricolleur,* harvester of signs.

The impact of such a declaration on the fine arts was extreme. A painting was no longer a painting, or even an object as such, but a locus of events, a kind of spectacle. The impact on photography was less obvious but in the long run even more profound. Photography's intrusion into the space of painting made it the tool of a self-conscious, critical avant-garde, with all of culture for its subject. Never had photography been marshaled to such an indiscriminate task, not even by the Bauhaus, with its goal of complete social transformation. In the process, however, photography was being turned against its own artistic aspirations.

In truth, the "art of fixing a shadow" had no language or province unique to itself. From the time of its inception

12

10 Edward Weston *Nude,* 1934 (printed 1970–71), gelatin silver print
Gift of Mr. and Mrs. William Lewis through the Friends of The University of Michigan Museum of Art

11 Sarah Van Keuren *Bride Revisted,* 1998, cyanotype and gum bichromate from pinhole negative
Photo courtesy of the artist

12 Robert Rauschenberg *Dwan Gallery Poster,* 1965, offset lithograph
University of Michigan Museum of Art, The Marvin Felheim Collection
© Robert Rauschenberg/Licensed by VAGA, New York, NY

13

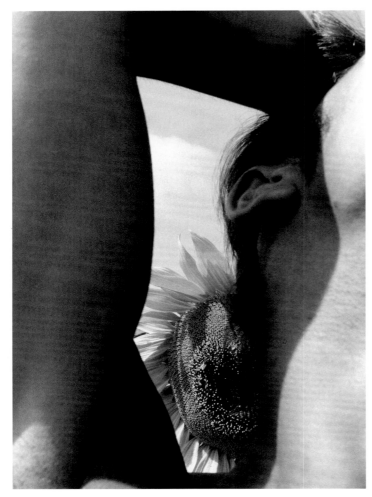

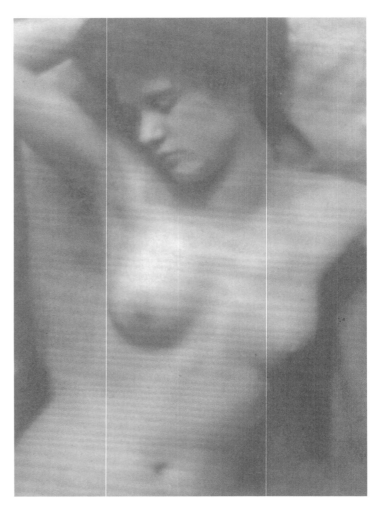

14

15

with William Henry Fox Talbot and Louis Jacques Mandé Daguerre, it was neither art, nor science, nor expression, nor mere mechanism, but all of them combined. Its status as an autonomous "art" was always borrowed, provisional, and contingent on the status of the other arts. The correspondence between emotional states and images, which Alfred Stieglitz had proposed as the foundation of art photography, was severed for photography and for all of art. As Rauschenberg himself put it, "There was a whole language I could never make function for myself. Words like 'torture,' 'struggle,' and 'pain.'. . . I could never see those qualities in paint."[8] Or, it goes without saying, in a pasted-down photograph of a man in a white suit, a parachute landing, or a bullfight. The Pop Art and conceptual movements reimplicated photography in the leveling of cultural hierarchies, reattached it to its factitious, commercial, and reportorial roots, and commandeered it for a variety of anti-artistic purposes, including the criticism of art as expressive form.

Andy Warhol, appropriately, added the finishing touch, with help from artists such as Sigmar Polke, Robert Stanley, and Chuck Close. They transplanted the photograph into other soil, into painting and silkscreen. Polke experimented aggressively with the possibilities of photo-chemistry and exploded the apparent unity of the image and its ingredients. Material competed with, and often overwhelmed, representation of the subject. The idea of the anecdotal photographic image and its cultural implications might survive, but its size was distorted and its surface, look, authority, and immediacy dissolved into Benday dots and pigment. Indeed, how could a photograph be an aesthetic object if it was no longer even a thing unto itself?

What was photography? By the end of the 1970s, the question had not been so open and unavoidable since Fox Talbot made his early experiments with a so-called mousetrap camera in order to show a view of the world as seen by a field mouse! The art of the 1960s and 1970s extended the crisis of the image to the last outpost of representation. In the process, it engendered most of the current strategies in photography. Photography began to give up its formal preoccupations and stylistic imperatives in favor of cultural criticism and intellectual program. This identity for photography—represented on the one hand by Sherrie Levine's deadpan appropriations of classic photographic images and on the other by Cindy Sherman's *Film Stills* series, which presents Sherman in stereotypical "Hollywood" poses—dominates the image making of our time.

Yet the postmodern challenge to art liberated other photographic possibilities inherent within the medium. Even before Rauschenberg began his combine paintings, he experimented with photograms and cyanotypes, two of the most primitive forms of photography. The same impulse that drove him to make them—to explore photography at its

13 Frederick Sommer *Max Ernst*, 1946, silver print
The J. Paul Getty Museum, Los Angeles, © Estate of Frederick Sommer
Courtesy of Pace/MacGill, New York

14 Ernestine Ruben *Sunflower*, 1988, gelatin silver print

15 Alfred Stieglitz and Clarence H. White *The Torso (Nude)*, July 1909
photogravure on paper, University of Michigan Museum of Art, Gift of Helmut Stern

16 Andy Warhol *Marilyn*, 1967, screenprint
University of Michigan Museum of Art, Gift of Frances and Sydney Lewis

123

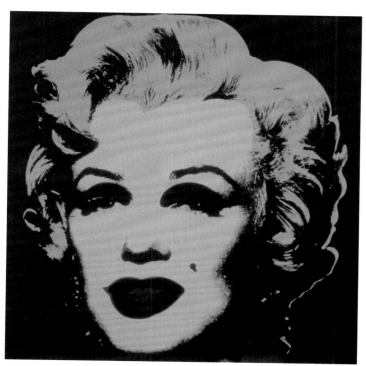

16

most basic level in order to understand the implications of its appropriation—also drove many artists toward what Stieglitz had long before referred to as "crooked" photography. The list of photographers who didn't quite play it straight is a long one, including now venerable figures such as Harry Callahan, William Klein, and Frederick Sommer. Art Sinsabaugh, a student of Callahan's, went even further. He adopted the panoramic banquet camera, commercially outmoded, as his primary format. In 1963 he wrote, "Today can and should be a time for those interested in the visual image possible through photography to advance the quality of this imagery by turning back to the techniques of the past I appeal for a critical reevaluation of the discarded techniques of photography to enhance the images of the future."[9]

Many artists took him at his word. Robert Fichter revived the cyanotype, invented in the early 1840s, and updated it with Florida imagery out of Ed Ruscha's repertoire of roadside signage. Robert Heinecken printed on wooden blocks, recalling the early decades when photographers printed on everything from mica to a woman's breast. A handful of people across the country began to experiment with daguerreotypes. Betty Hahn, then at the University of Rochester and in the orbit of the George Eastman House Museum of Photography, used gum bichromate to create a sequence of images that seemed to hover between film stills, prints, and snapshots. The images managed to suggest at once the nineteenth-century motion studies of Eadweard Muybridge, contemporary street photography, and collage. What had been done in the nineteenth century out of curiosity, technical expedience, or economic necessity might now be done as a matter of artistic choice.

It is easy to see why so many of these artists, coming out of fine art backgrounds, fomented discord in conventional photography programs, Sinsabaugh's advocacy notwithstanding. It was one thing to contest what was regarded as acceptable content in images. That had been going on in Western art for centuries. With Warhol's permission, however, Pop artists proposed to strip the photograph of its silver gelatin skin, to sacrifice its luminosity, its silver trace of light, its transparent essence, in the pursuit of a wider range of effects. When Betty Hahn secured a teaching job at Rochester, she took over the position previously occupied by Minor White, whose mentors had been Adams and Stieglitz and who co-founded *Aperture.* Considering Minor White's near-mystical belief in the expressive inner truth of photography, sacrilege is not too strong a word.

Is there a revolution, one that includes artists such as Ernestine Ruben? After all, even White was willing to crop an image ruthlessly if it didn't suit him. The print was not sacrosanct. As with painting and sculpture, however, photography undergoes a transformation with the conscious

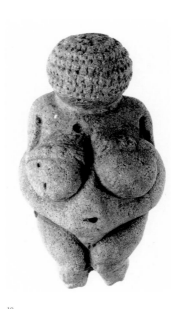

19 *The Venus of Willendorf,* circa 25,000 BC, limestone
 © Naturhistorisches Museum Wien, Photo: Alice Schumacher

20 Ernestine Ruben *Dark Twist,* 1996, platinum print on paper pulp

21 Ernestine Ruben *Horizontal Columns,* 1995, platinum print

22 Ernestine Ruben *Victor Hugo,* 1996, platinum print

embrace of all its valences, an embrace not possible until now. Photography acquires a history and perhaps even a special province at the moment it becomes fully self-critical. This process, as we have seen, is enacted by artists in an encounter with both the historical situation and the materials of photography—light, metal, paper, chemicals. For the antiquarian avant-garde, and for all photographers, the past is available, meaningful, and problematic, and the art produced is self-doubting and aware. It can be joyful, meticulous, sensual, imitative, antagonistic, and reverential. What it cannot be is naive.

With this renewed attention to materials and surfaces, we come close to arguing that each photographic process has its own perfect images, and that these are not translatable to other formats. The daguerreotype, tintype, and ambrotype (a positive image on glass), for example, can be used as printing media for standard negatives, rather than being shot "in camera." At first sight, this seems cheating, a kind of mongrelization, as photographer Brett Weston might have termed it. Practically, the results of any process are unpredictable and often revelatory. The hands-on nature of old processes increases the variability of the outcome, guarantees multiple, unique variants of a single "image," and undermines the accepted dogma (post-Walter Benjamin) of the photograph as multiple. A daguerreotype made from a negative by Adam Fuss, or a gum bichromate print from a negative by Ernestine Ruben, yields a variable, three-dimensional object, inevitably different from all sister object-images, no matter how tightly controlled the processing.

Far from banishing digital technology, old processes allow for multiple digital interventions. It is important to distinguish between digital capture, digital outputs such as ink-jet prints, and image readings. Digital reading of an image, say on a computer screen, tends to privilege certain aspects of an image's information. The computer screen cannot register texture at all, and this accounts in part for the horror many photographers feel toward the computer. Likewise, the creation of digital images means that conventional darkroom strategies for the negative are out the window. In essence, the digital image is objectless. But all data is bodiless, and barriers of translation have been falling since the camera made its appearance. The digital camera allows for image delivery and reproduction in any mode. These outputs can be said actually to "create" the image, which is simply a detailed digital suggestion. In the opinion of alternative process guru Christopher James, the photographic future is not one of "either/or" but "both/and."[10]

Ernestine Ruben embraces this brave new world, antiquarian and avant-garde, a world ready for the application of new skins. She is working with digital negatives and gum bichromate, varying the outputs, mixing media,

and seeking optical surprises. She is also experimenting with digital Iris prints on handmade paper. By the same token, she is ready to renounce advanced technology when the art demands it. In 1997, she collaborated with paper sculptor Jan Cincera to create an installation about the ancient city of Petra, in the Jordanian desert. Cincera made paper on location to recreate the tones and textures of desert rock, while Ruben made platinum photographs to convey the site's contours, situation, and light. She developed the pictures on the spot in water and printed them out in sunlight, as the earliest photographers would have done. Later, she and Cincera devised a way to combine physically the two paper media into three-dimensional objects. "My responsibility as an artist," she once remarked, "is not to perfect technique or wed myself to process. It is to carry out a concept, to realize an idea. I want to extend the idea of the 'antiquarian' back beyond early photography to the origin of all forms of representation, to the impulse to make art." [11]

If anything, this statement reveals where Ruben parts company with cooler and more calculating conceptual photo artists. Her intention is not criticism of the medium and least of all historical reference. Rather, she is engaged in a process of artistic purification using whatever "impure" means are available. Her interest in the origins of art and in landscapes laden with spiritual associations, her search for the appropriate form for intuitions of timelessness, show her to be a contemporary Romantic, an inheritor of a sensibility that crosses media and reaches back through Steichen and Rodin to William Blake and earlier celebrants of the human form. I think of Caravaggio, Verocchio, and, jumping a few millennia, the anonymous creator of the Venus of Willendorf.

For all these artists, to make a representation of the body is to overcome absence through participation in the process by which bodies themselves are brought into being. In primitive thought, the desire is to gain access to the sacred power governing fertility. In secular thought, it is to transcend time, which is seen as the ultimate enemy of all bodies. So Ernestine Ruben strips the silver skin from the photograph only to apply it as a new skin to bodies, a radiant, protective clothing. Cloaked in the silver skin, bodies lose their pasts and their individual destinies. We see them as all that they are and nothing more. Yet the body bears consciousness into the world and so is the phenomenon that, for us, makes all others possible. To make an image of it in Ruben's terms is to express the most extravagant desire of all, to contain all the world in one instant, one place, one form.

Notes

1 Rainer Maria Rilke, "The Rodin Book," in *Selected Works,* vol.1, (New York: New Directions, 1960), p.139.

2 Ernestine Ruben, gallery announcement, The Platinum Gallery, New York, 1997.

3 Rainer Maria Rilke, *Letters of Rainer Maria Rilke* (New York: W. W. Norton, 1954), p. 83.

4 Conversation with the artist, July 2000.

5 Lyle Rexer, "Photography's Antiquarian Avant-Garde: Reviving Long-Obsolete Processes," *Graphis* 320 (March/April 1999), p. 73.

6 Nancy Newhall, *The Eloquent Light* (Millerton, New York: Aperture, 1980), p. 69

7 Beaumont Newhall, ed., *The History of Photography from 1839 to the Present Day,* (New York: The Museum of Modern Art, 1982).

8 Mary Lynn Kotz, *Rauschenberg/Art and Life* (New York: Harry N. Abrams, 1990), p. 90.

9 Art Sinsabaugh, in *Six Photographers* (University of Illinois, Champaign Urbana, 1963)

10 Conversation with the artist, September 2000.

11 Conversation with the artist, July 2000.

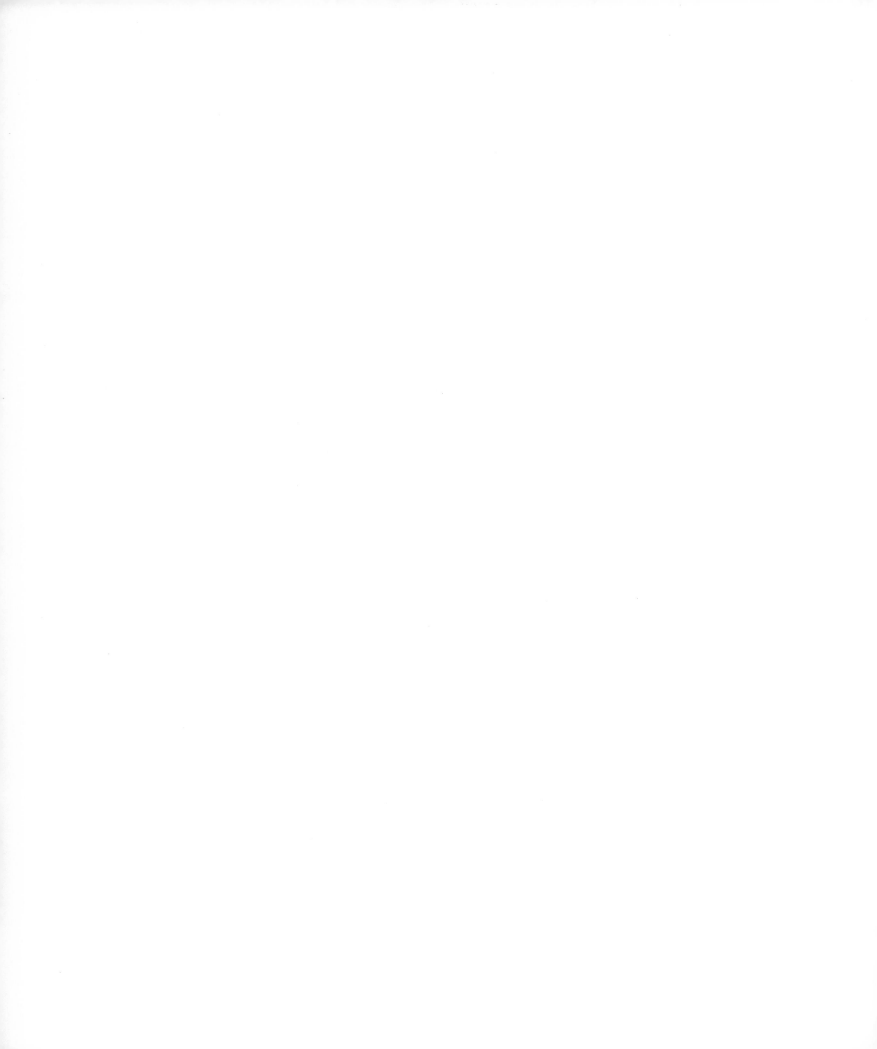

plate 55

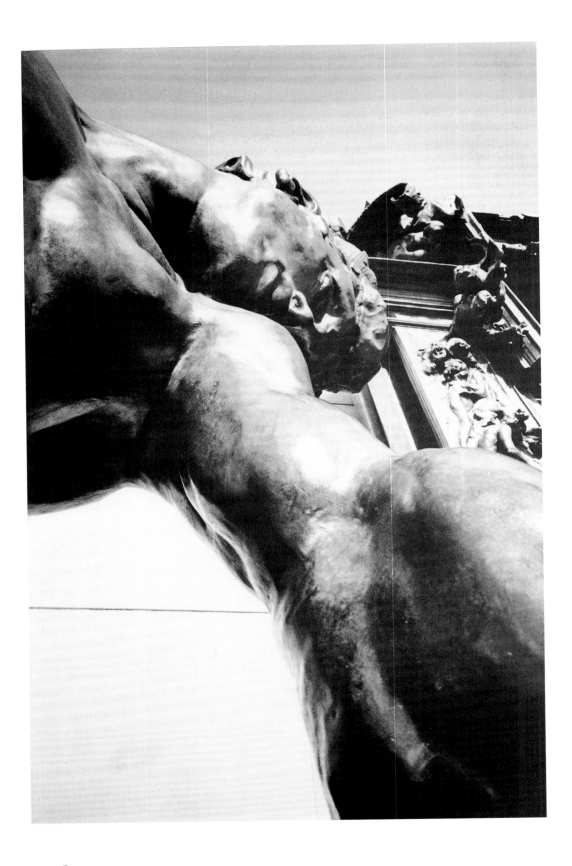

plate 56

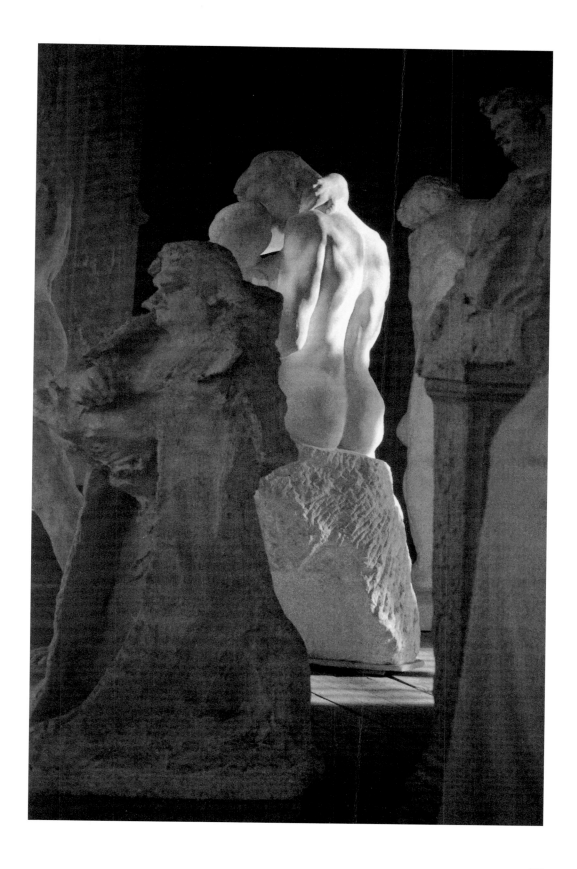

plate 57

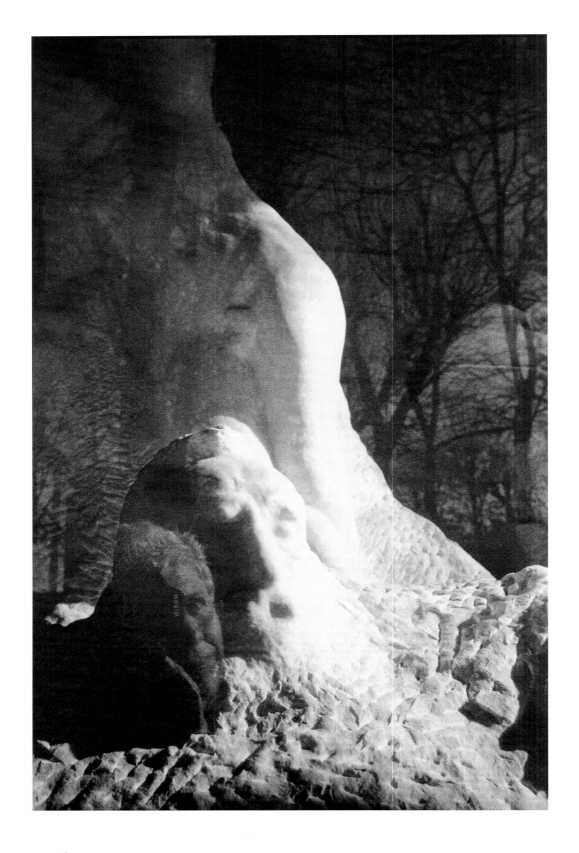

plate 58

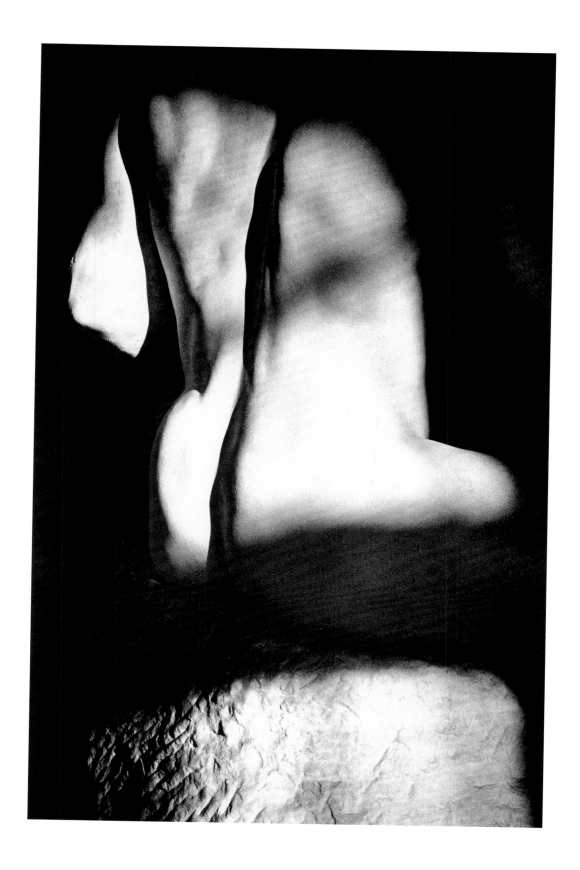

plate 59

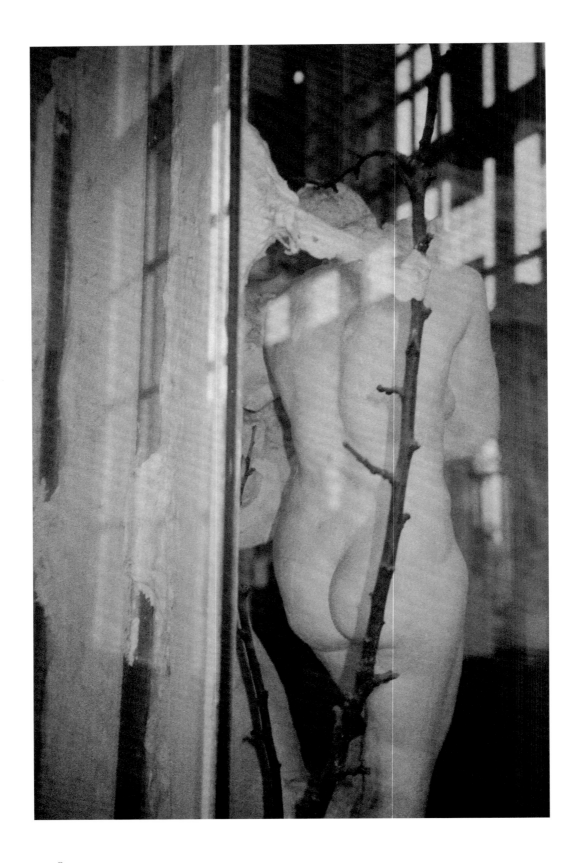

plate 60

plate 6I

plate 62

plate 63

142

plate 64

plate 65

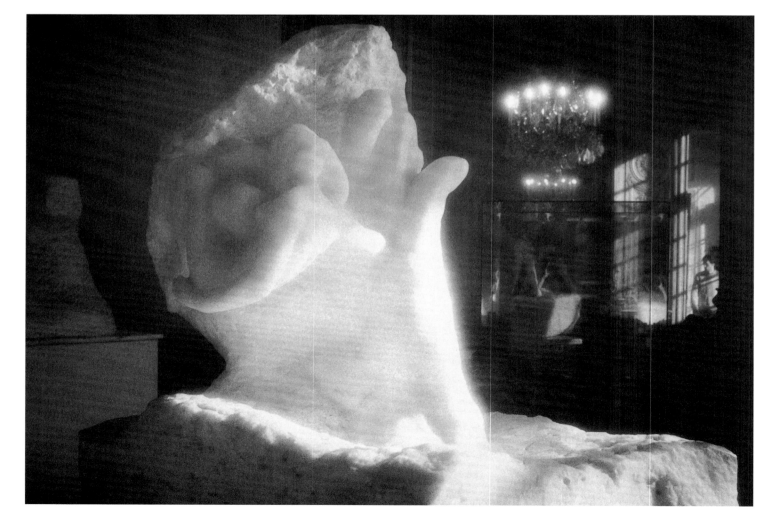

plate 66

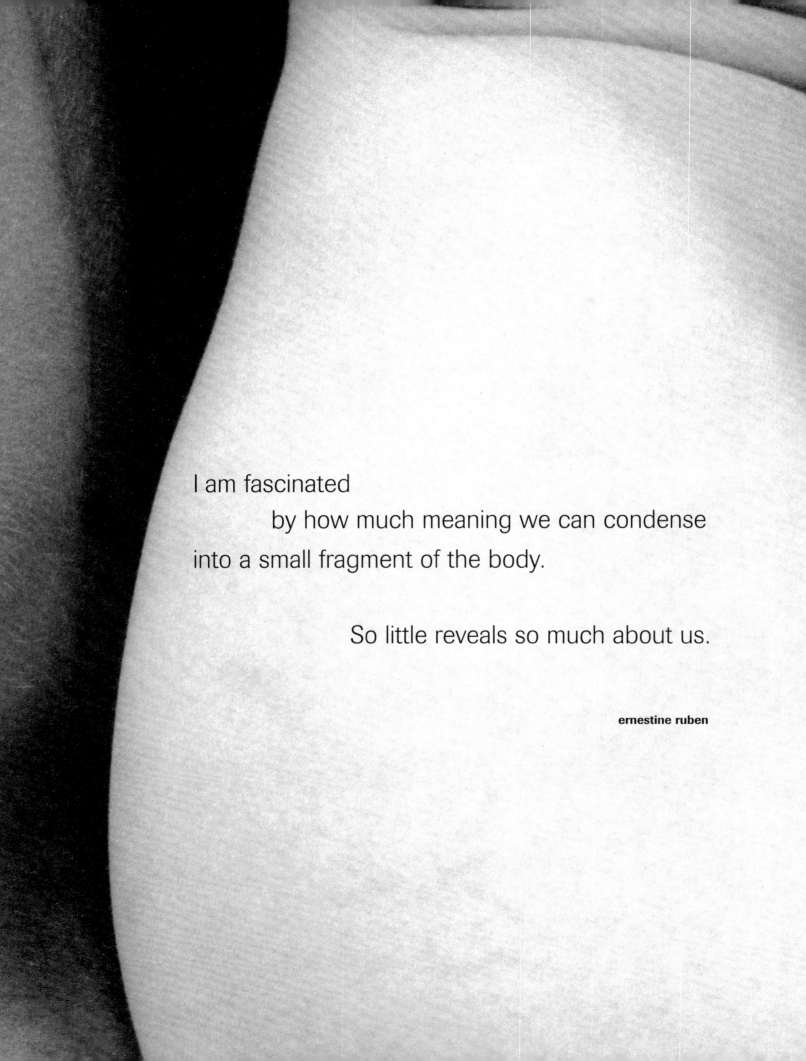

I am fascinated
 by how much meaning we can condense
into a small fragment of the body.

 So little reveals so much about us.

ernestine ruben

contemplating touch

serge tisseron

What do Ernestine Ruben's nudes from the 1980s, photographed in close-up, have in common with her photographs of the 1990s, which superimpose upon each other elements of landscape and fragments of the human form? On first glance, nothing, yet there is a filament that connects the two periods and the works that derive from both strands. That filament is skin, considered in its multiple aspects—as a surface of containment and of contact between bodies, as a visually complex material, and as a substance that can stand as a metaphor for photography itself.

Touching with a Lens

Ruben isolates fragments of male and female bodies in tight close-up: the roundness of a shoulder, of an Adam's apple or a knee, the furrow of a palm or of a neck. This game with forms sometimes cultivates a troubling ambiguity: does this body fragment belong to a man or to a woman (*Teenage Arms,* 1981)? Is this black skin, or white skin plunged into shadow (*Neck to Neck,* 1983)? Is this hand that slides along a torso male or female, and does it belong to that body or to another (*Peekaboo Fingers,* 1987)? But these questions about identity, experience, and the human encounter are, for the artist, inseparable from a profession of aesthetic faith. Preferring, as she does, the crooked to the straight, the round to the pointed, the soft to the hard, Ernestine Ruben touches the heart most deeply when she turns her back on an invocation of neoclassical aesthetics to tell a story about the tender love of a shoulder and of a chin (*Architectural Neck,* 1981), of a palm and of an armpit, or a hip and a but-

tock (*Zurich Invitation,* 1988), exploring and caressing the body. In this quest for proximity she inevitably encounters both the fragment and the skin as the extreme limits of such rapprochement.

Drawing ever nearer to the thing observed can result in the ability to see but a small piece of it. When the object observed is a human body, the viewer also confronts the skin with its textures and reliefs. This appears to be the goal of the artist, whose nearness and focus on the part more often than the whole is motivated by a desire not to control bodies by dividing them into pieces, but to caress them with her lens, exalt the skin that covers them. If she encounters parts of the body more than its whole, this derives from a desire to be ever nearer to it. Using her camera as an extension of her own body, she gains direct experience of other bodies, engaging with them as lover and voyeur—an extension of her own creative act.

There are similarities between the film that we slide into our camera and the skin that constitutes our corporeal envelope. Photographic film is a virgin surface concealed in a case, much like a body in a mother's womb. As soon as film is exposed to the light, it, too, is bathed in solutions, revealed, and named, like a newborn. This birth marks the beginning of inevitable decay—shriveling up and cracking after exposure to rain and sun, becoming covered with spots as the years pass—linking photographic film and human skin, including that of the artist, in a strong metaphoric relationship. (This relationship exists with the artist's paper and canvas, of course, but much less dramatically—for they

1

2

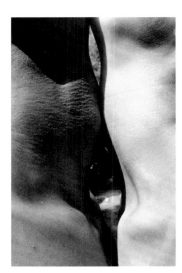

3

1 Ernestine Ruben *Peekaboo Fingers,* 1987, gelatin silver print

2 Ernestine Ruben *Teenage Arms,* 1981, platinum print

3 Ernestine Ruben *Neck to Neck,* 1983, gelatin silver print

4 Ernestine Ruben *Architectural Neck,* 1981, gelatin silver print

5 Ernestine Ruben *Fred on Tire,* 1983, gelatin silver print

bear the marks of the artist from the first and only suffer the effects of time secondarily.) The photographic skin bears the marks of light—including accidental markings as well as the inevitable signs of aging—like the human skin itself. Thus the visual world developed by Ruben uses the body, skin, and softness as metaphors for contact between competing or complementary "envelopes" of humanity, captured and revealed on film.

Hands play an essential role in the formation of the strange, polymorphous, unexpected objects in the first images by Ruben (*Cradle of Toes,* 1987). Sometimes the hand appears in the image like a welcome visitor beside the trembling body that it approaches (*Fred on Tire,* 1983). At other times, it's a familiar animal (*Jaime's Fist under Chin,* 1987), appearing like a vulnerable baby warmly welcomed by a corporeal crease (*Hand,* 1981; *New Born,* 1981). Or the hands may be markers of the deformation of the model's body (*Choke,* 1987; *Original Hands,* 1985). They are the first subjects of her photographic superimpositions, sometimes presented like fragile children that she must care for, bundle up, and educate after each creative rebirth. But for Ruben, hands are not only an important recurring motif in her images; they are also the means of transforming creation itself.[1] Her work—from her photographic super-impositions, to her images of fragments of the human body that are posed and positioned in mirroring juxtaposition, to her rediscovery of the gum bichromate process, a medium dating back to the earliest days of photography—is carefully hand-wrought.

Just as her photographs of the naked body explored links between human fragments of different sexes and races, Ruben's superimpositions explore links to the world of nature—stones, streams, and vegetation (*My Poor Left Hand,* 1988; *Hand Bush,* 1988). Instead of body and body, they pair body and nature. Contact here no longer means bodies brought together physically, captured in a single frame. In these photographs, parts of the body accentuate certain aspects of nature—as form or matter—while continuing to assert themselves for their own essence. These superimpositions are, depending on one's point of view, fragments of bodies, fragments of the world, or revelations of the infinite resonance that link one to the other.

Whoever examines his mirror, examines his identity, and often doesn't recognize himself. Isn't the mirror always distorting? It is difficult to find a mirror in which we see ourselves in the way in which we desire to be seen. But if the distorting mirror twists what is straight, could it not also straighten what is twisted? Transformation by mirrors is in keeping with the dynamic of the skin. Skin is a little like the mirror of our existence through the traces that it bears like memories—tattoos, wounds, or signs of aging. Ruben prefers round mirrors. The transformation

that they impose on the world evokes the feminine round-
ness of her first photographs. Such a mirror rounds off
the angles of houses, the points of chimneys, and the sallies
of elbows and knees. Whether examining the reflection
of the human form *(Hommage to MP,* 1987), or distorting
the cityscape *(Round Brooklyn Bridge,* 1986), or injecting
a whirling sense of chaos into the static landscape *(Diane
in Whirl,* 1998), Ruben's mirrors transform the world into
an ensemble of shoulders and hips, offering a caress and
feminizing everything they reflect.

 In Ruben's photographs from the 1980s, the artist's
inquiry into the relationship between surface and framing
involves devices of staging and pose. The models are often
photographed in twos, in troubling proximity. Her inter-
posed lens revels in the intimacy of their touch and the tex-
ture of their skin. With these works, as with those employing
the mirror device, we never know whether these parts of
the body or skin are in the process of uniting or separating
or whether the lens of the photographer is moving away or
moving closer—an uncertainty that serves to remind us that
a photograph is achieved through a combination of the
artist's point of view and the focal distance. Working with
gum bichromate gives Ruben greater technical flexibility
in exploring (and exploiting) these contests of contact and
proximity and the effects they produce on the viewer.

 In the gum bichromate technique, a unique image—
a monotype—is built up layer by layer, skin upon skin.
Images such as *Claudia in Flurry* (1998) and *Diane in Whirl*
(1998) carry within them the evidence of the successive
steps of their creation and present encounters akin to the
body-to-body encounters in Ruben's photographs from
the 1980s. The subjects appear to be floating, ephemeral,
as if captured in the process of wearing away *(Ulricke Head
Straight Up,* 1998; *Ulricke Head Up to Right Side,* 1998).
The indistinctness of movement toward or away from the
body in the earlier work is displaced in favor of an interroga-
tion of the origins and fate of the image. Is the haziness a
temporary state, soon to sharpen into a triumphant clarity?
Or, rather, is this haziness a definitive state, destined to
progressively extend itself onto the world and our spirits,
as in *Heinz Bent to Right* (1998)? Depending upon the particu-
lar image and the viewer's state of mind, the viewer may
experience the effect of an ephemeral apparition as well
as a sense of anguish at the anticipated loss and dissolution
of the object. The latter sensation is a likely response to this
work, being rooted in the psychological processes related
to loss that most of us experience as we mature.

 Consider, for example, a child who plays in the
presence of a parent or other adult on whom he or she
depends. While seeming to be preoccupied with toys and
friends, the child still needs the reassuring presence of the
adult. At this point, the child has not yet fully internalized

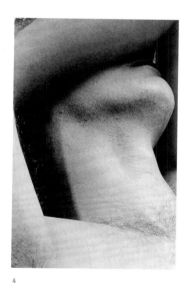
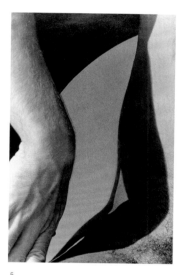

4

5

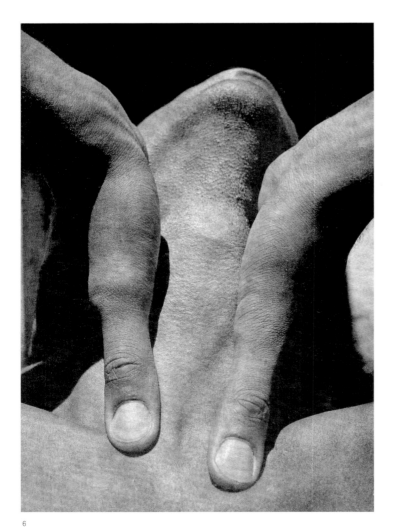

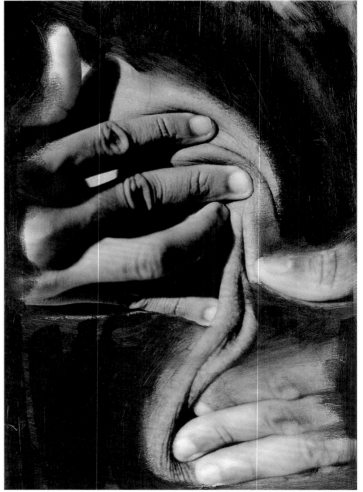

6

7

this stable adult figure; it may seem to vacillate, or even to threaten to disappear. So the child will turn toward the real adult accompanying him and watch, speak to, or even touch him. This reinforces the child's internal sense of the adult's strength, so that once again, the child can ignore the parent and resume playing.

Anxiety over the obliteration of the loved one is familiar to anyone in romantic love. At first, frequent contact with the loved one is required, and it is only little by little that one succeeds in conjuring up or dreaming about the person during his or her absence. But in the moments when the image that we have constructed for ourselves is no longer strong enough to reassure us of the bond, real contact becomes necessary. Without it, fear grows that the image of the loved one will become hazy and increasingly indistinct.

The indistinct images created by Ernestine Ruben call upons us to confront our fear of loss, our own hazy internal images, and our need to preserve, clarify, and lean on them. [2] But the blurred image need not necessarily call forth anxiety. It can also serve as a reassuring reminder of the world's ability to surprise and delight, as when something progressively emerges from a fog, revealing itself as better than first imagined and affording added pleasure in the act of discovery. Nostalgia for what is lost, the joy of discovering the new: these opposing perspectives are captured in the words of the Roman poet Ovid, who wrote that "everything alive is approaching death," and the words of the Greek philosopher Epicurus: "nothing dies, everything transforms itself." Those who find Ruben's images melancholy and "embalming" will miss the excitement of the infinite power of transformation that they also imply. I sometimes imagine that the artist dreams of herself as a plant, blooming with verdure and sending forth leaves with renewing energy each year. Her gum bichromate images capture this vitality and convey the artist's ability to be surprised by the world; they invite us to make ourselves available to the world's changes and open to our continually renewed desires. [3]

The Stability of Stone

Ernestine Ruben's photographs of the work of the sculptor Rodin bring together many themes expressed elsewhere in her work—a contradictory longing for both stability and change, the timeless and the momentary, the anticipated and the remembered. At first glance, it seems appropriate to classify her photographs of the statuary of Rodin as another expression of her interest in fragments of the human body, and thus to see in them a continuity with her work from the 1980s and 1990s. Conscious of their shared fascination with the body—especially the neglected, overlooked male body (*Balzac in a Frock Coat,* 1996; *St. John from Burghers of Calais,* 1997; *Balzac with a Beam of Light,* 1997)—Ruben found in

8 9

6 **Ernestine Ruben** *Choke,* 1987, platinum print

7 **Ernestine Ruben** *Original Hands,* 1985, gelatin silver print with paint

8 **Ernestine Ruben** *Claudia in Flurry,* 1998, gum bichromate print

9 **Ernestine Ruben** *Diane in Whirl,* 1998, gum bichromate print

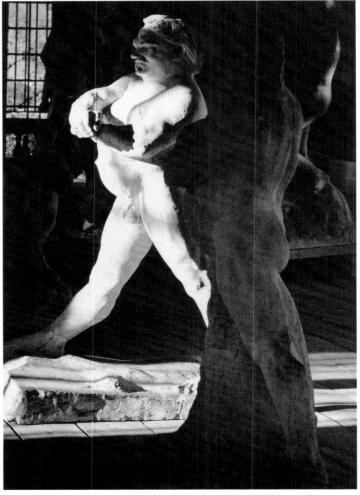

10

11

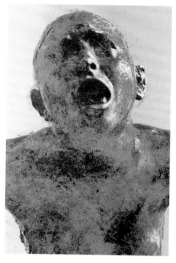

12

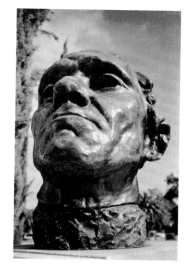

13

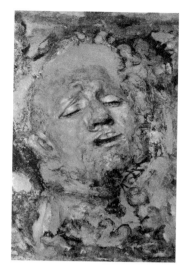

14

Rodin not only the lover and master of Camille Claudel but a bit of herself, a guide to a different sort of exploration of the human form. Unlike her work of the 1980s, which explored the silky, soft bodies of youth, that of the 1990s features Rodin's tortured forms: a face deformed by a cry (*The Cry with Patina,* 1997), the agonizing hand of "the illness of Dupuytrens" (*Dupuytrens Red,* 1996), the resigned expression of the Burghers of Calais (*The Head of Jean d'Aire,* 1996; *Pierre de Wiessant Beige,* 1997). Through these images, as with the hesitant and moving photographs created in gum bichromate, Ruben continues to explore the contradictory aspects of the photograph in time. Her manner of photographing a face, the twisting of a bust, or the suggested movement of a head almost appears to restore movement to the sculptures and life to the stone. At other times the image gives us a privileged moment captured in time (the artist's time), such as a slanting or undulating light in a propitious season. Through these suggestions she shows us that photography is not condemned merely to fix a moment from the past; she puts the viewer's imagination in action to prolong our observation of the world by anticipating its movement.

The desire of the human being to make images is constantly shaped by two opposing aspirations, two contradictory impulses toward space and time. The first poses space as a territory to be conquered and the passage of time as a menace to be mastered. It sets up the terms of representation and halts the defilement of time through a myth of absolute control. The second of the aspirations renounces domination, throwing in its lot, instead, with sensation and participation. The former glorifies the splendid, isolating mirror. The second opens sight to the troubling dimensions of the body and of time.[4]

Ernestine Ruben, in combining work on young and old bodies, on flesh and sculpture, on surfaces and contacts, arouses the desire to witness touch and to see skin close up—and the desire to *transform,* which is linked with seeing in an inseparable manner. In French, *toucher* signifies "entering into contact," and *toucher juste* means "reaching the goal." Ernestine Ruben *touche juste la peau* (reaches the heart of the matter) in these two different respects: her work ushers us into contact with the skin, and through the metamorphoses that she employs, she touches the heart. *(Elle touche juste.)*

Notes

This article is translated from the French.

1 I found out later, when I had already noted the importance of hands in her photographs from 1988, that Ernestine Ruben was suffering from a joint problem, which obliged her to have regular operations. Hands were not for her, some things among others, but menacing instruments.

2 Consult my work on the subject, *Petites mythologies d'aujourd'hui [Little Mythologies of Today],* (Paris: Aubier, 2000), most notably the chapter entitled "Tout est flou: faites des photos nettes." (All is fluid: making clear photos).

3 My work *Le Mystère de la chambre claire: Photographie et inconscient. [The Mystery of the Camera Lucida: Photography and the Unconscious],* (Paris: Les Belles Lettres, 1996; reissued by Flammarion, 1999), is devoted to the exploration of the photograph, not as testimony of a completed past, but as an accompaniment in a world to come.

4 Concerning this aspect of our relationship to images, consult my work *Le Bonheur dans l'image [Happiness in the Image],* (Paris: Les Empecheurs de penser en rond, (Spoil Sports), 1996).

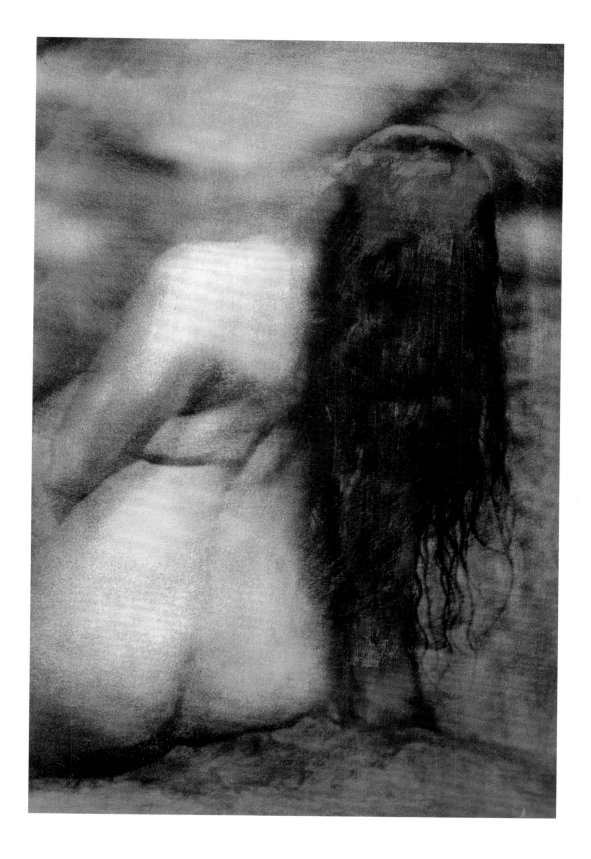

plate 67

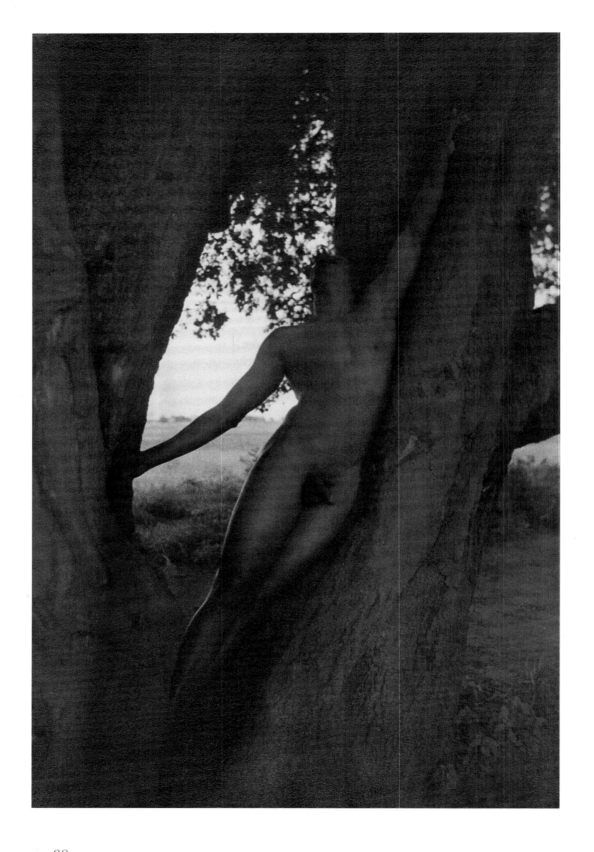

plate 68

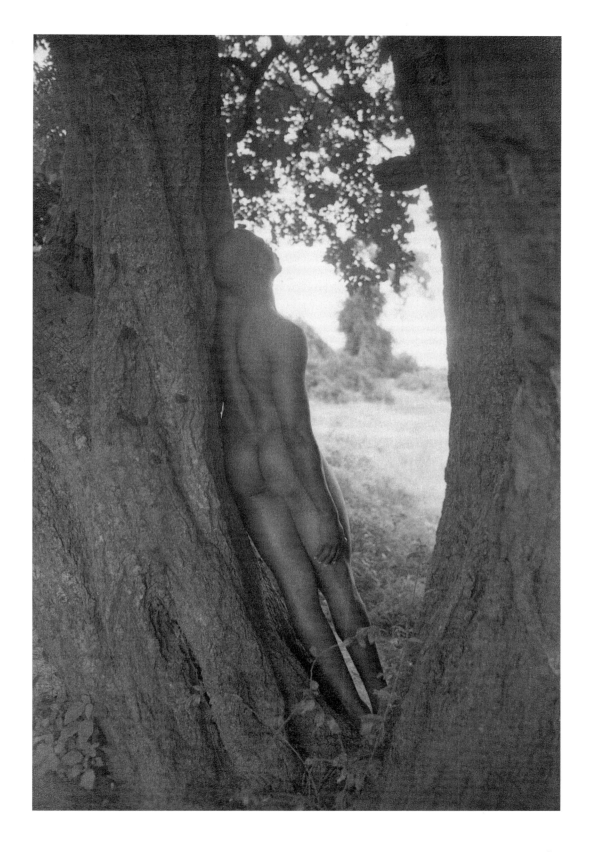

plate 69

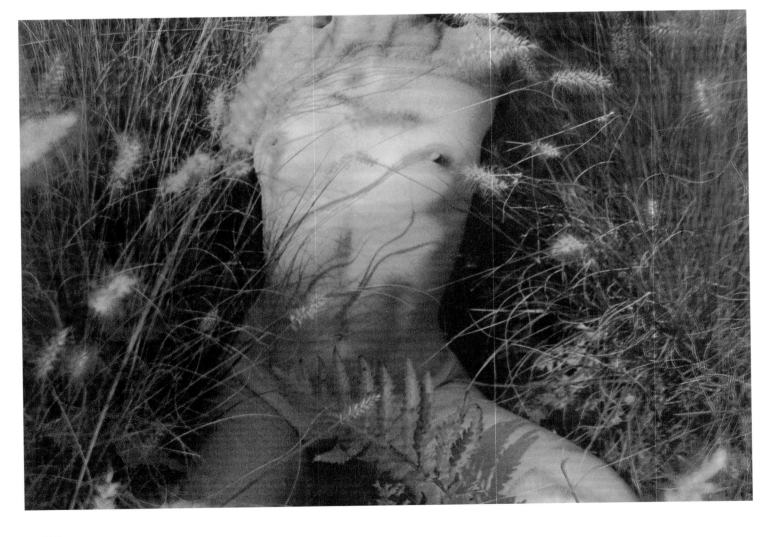

plate 70

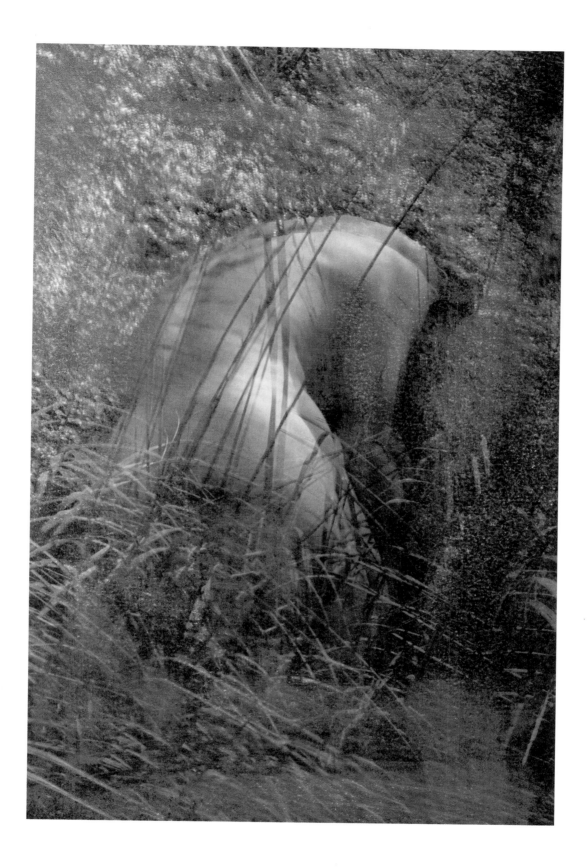

plate 71

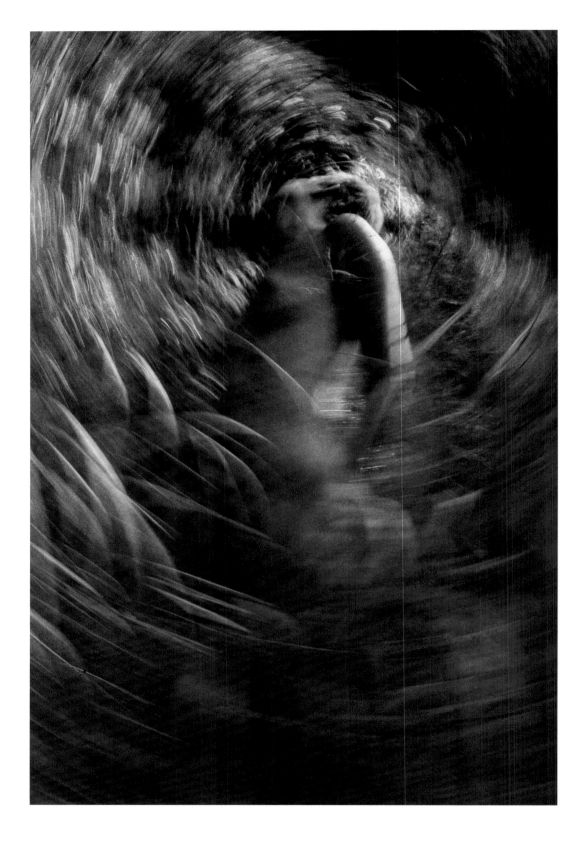

plate 72

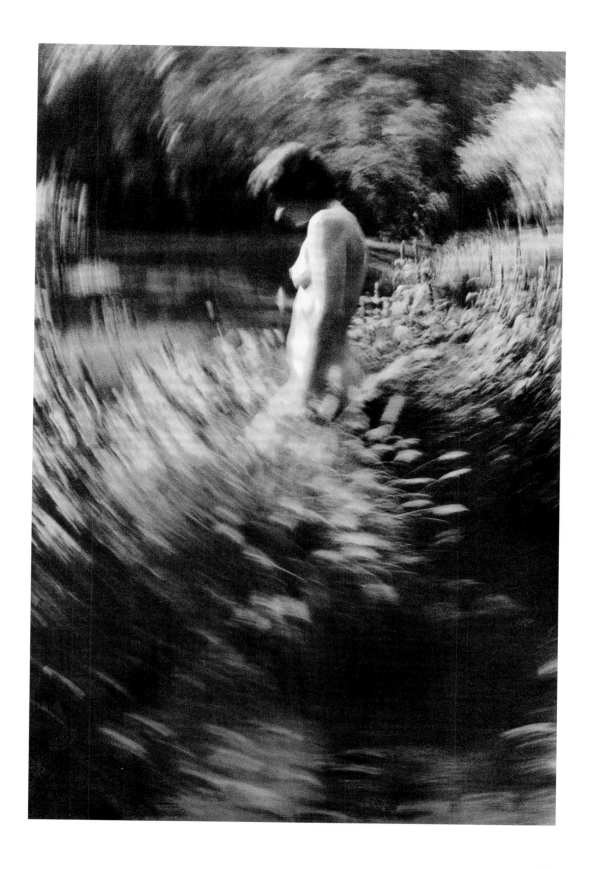

plate 73

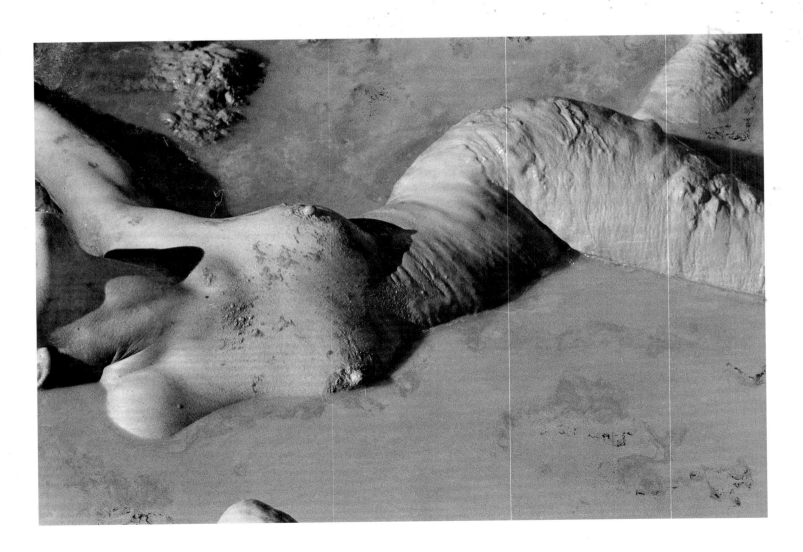

plate 74

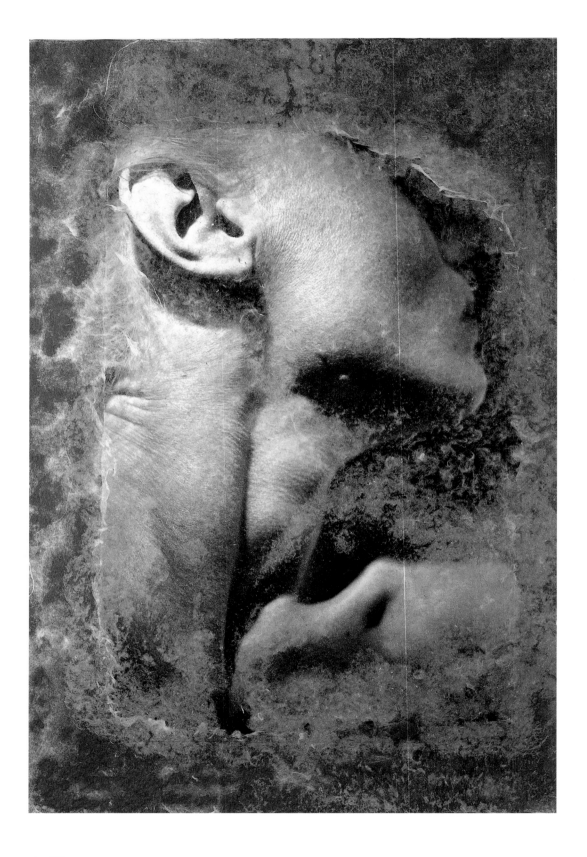

plate 75

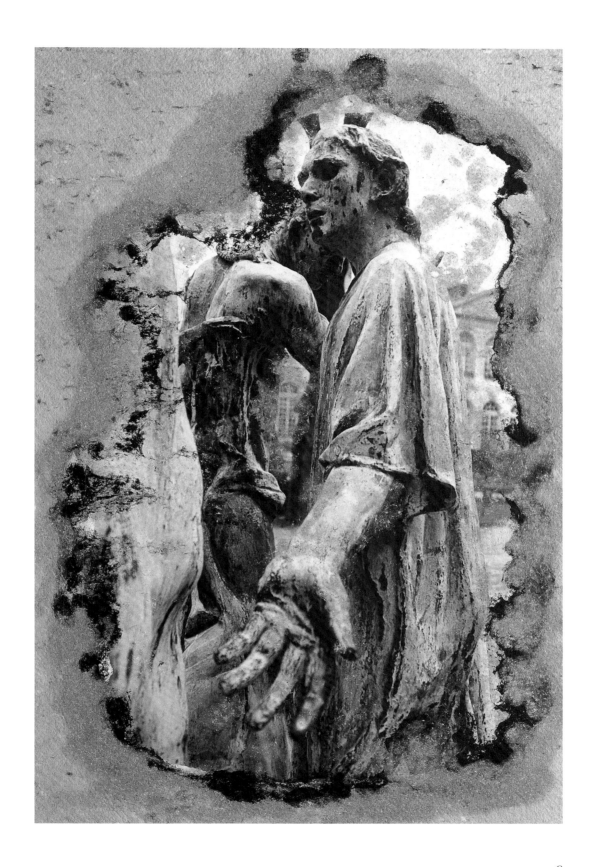

plate 76

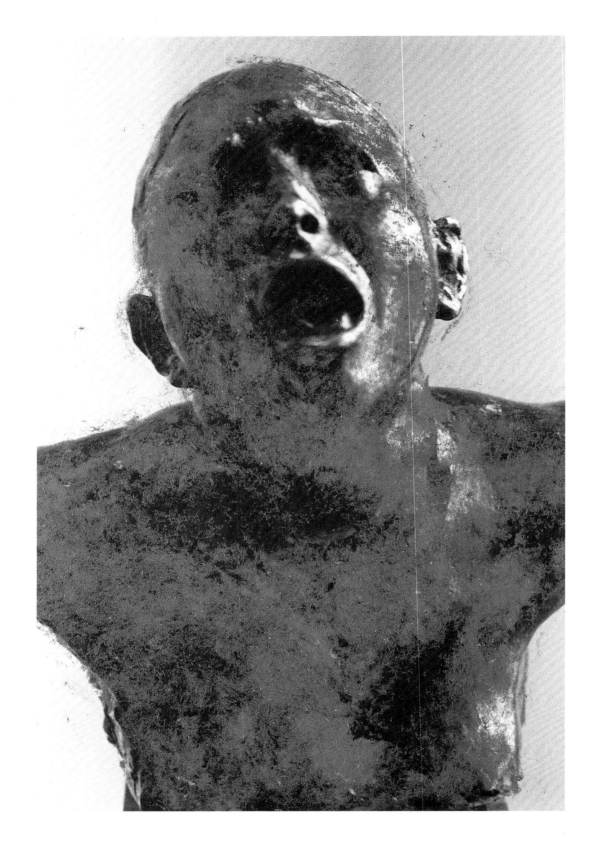

plate 77

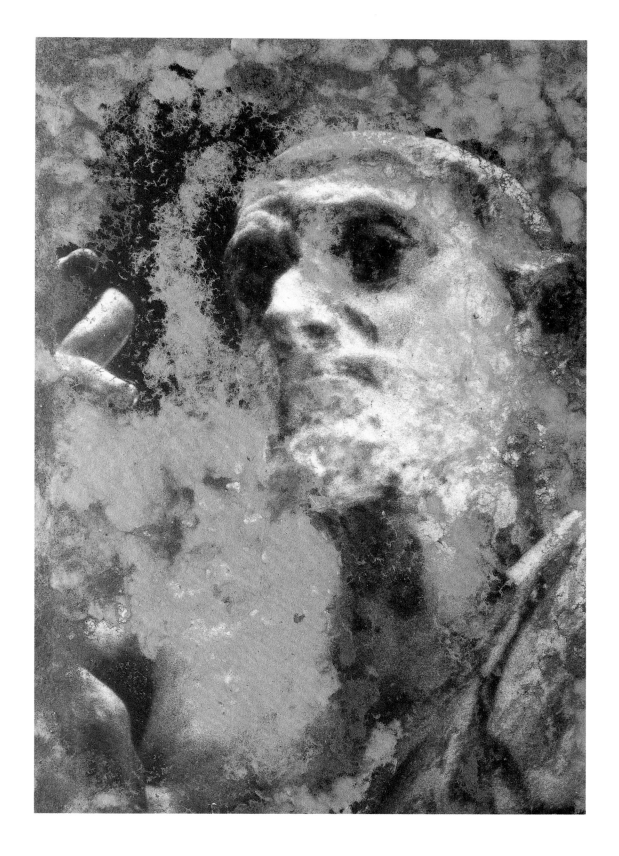

plate 78

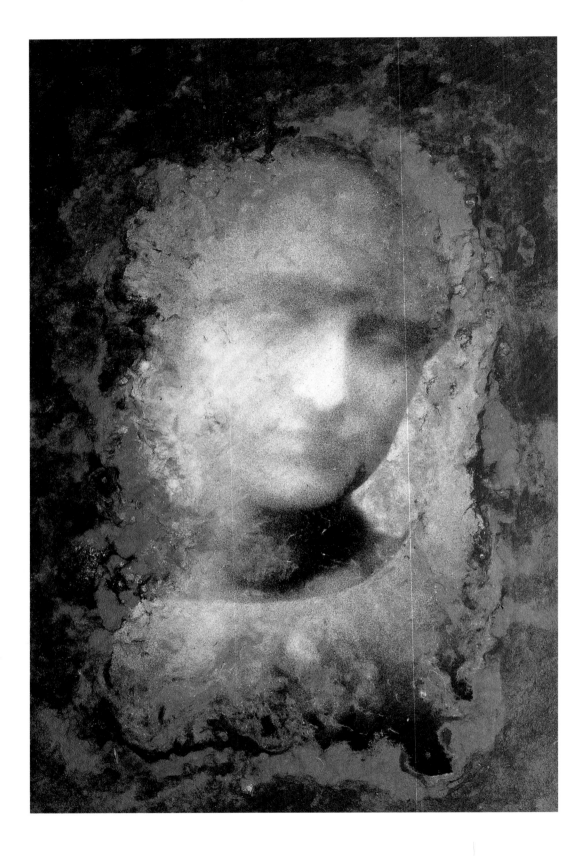

plate 79

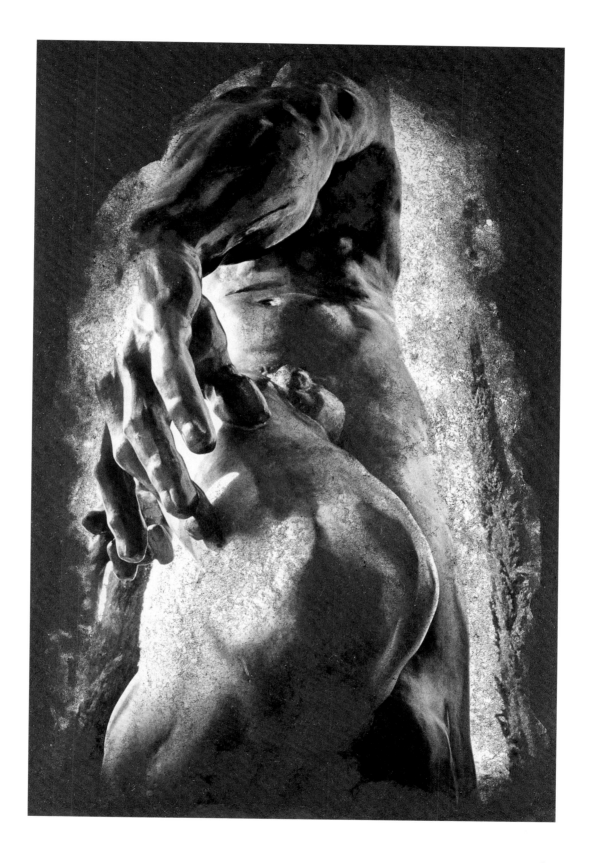

plate 80

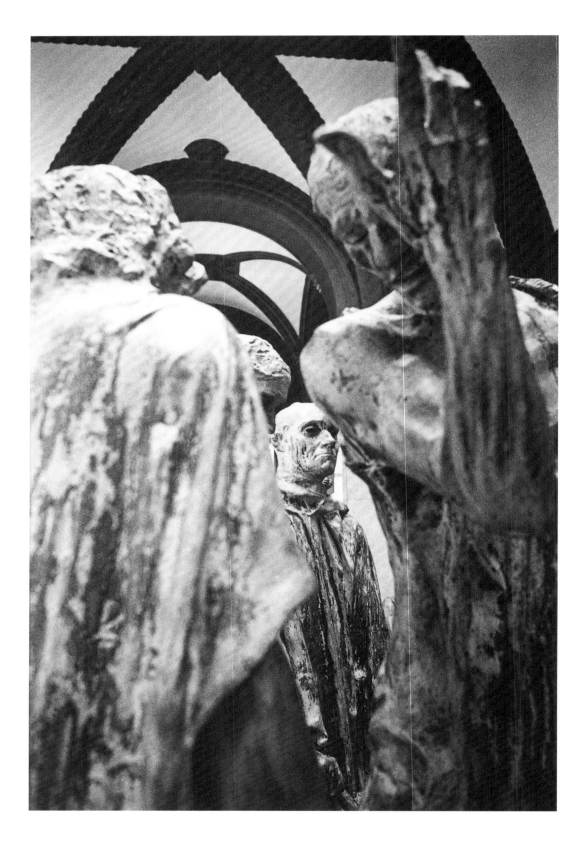

plate 81

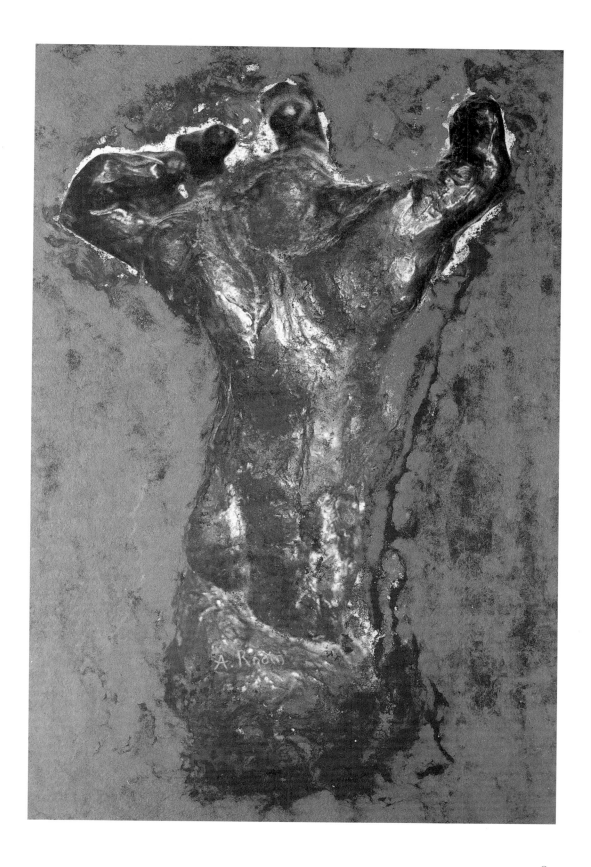

plate 82

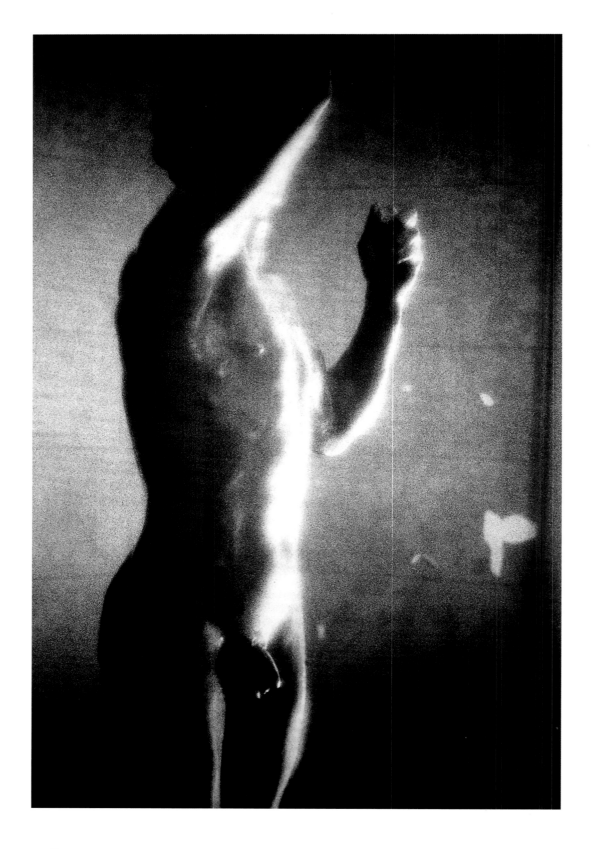

plate 83

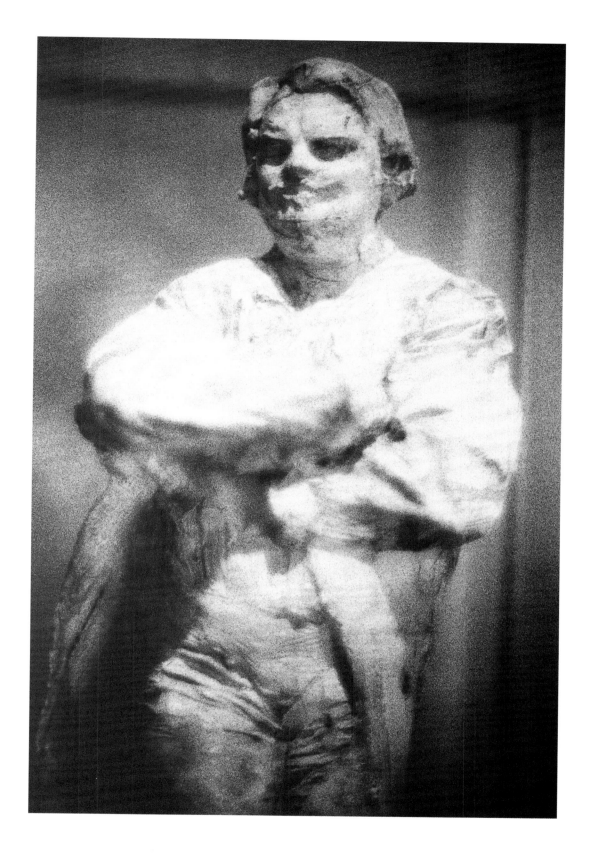

plate 84

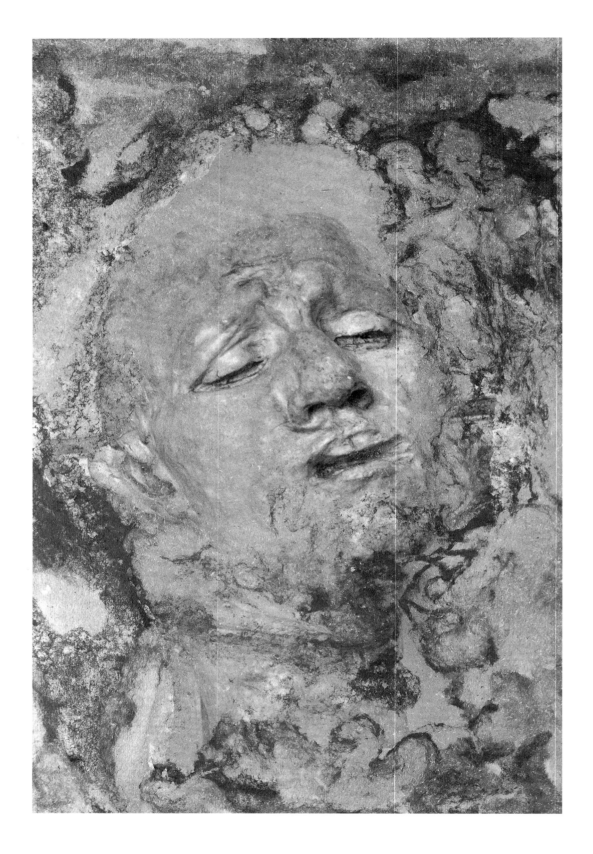

plate 85

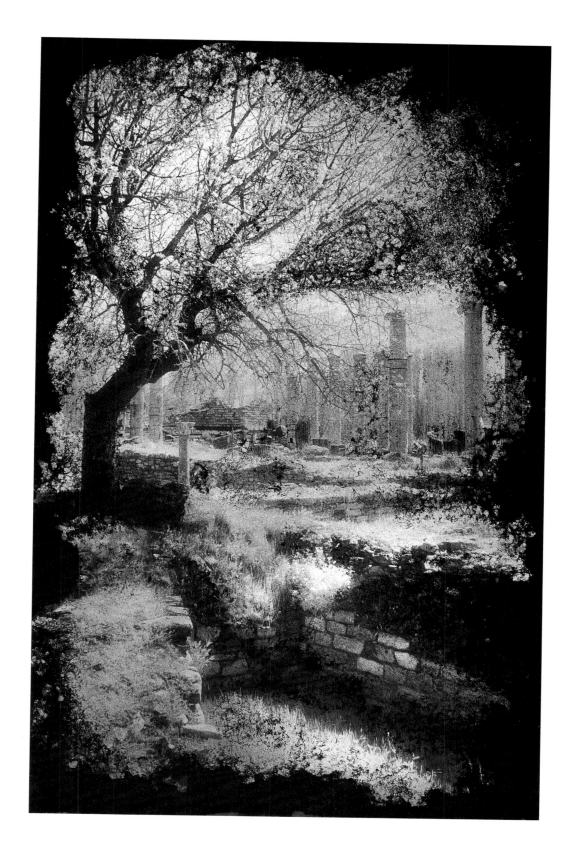

plate 86

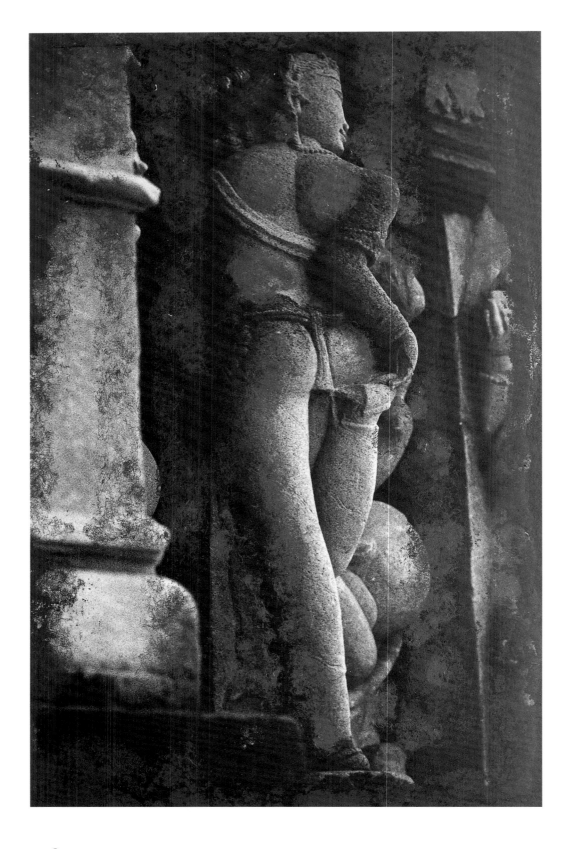

plate 87

plate 88

plate 89

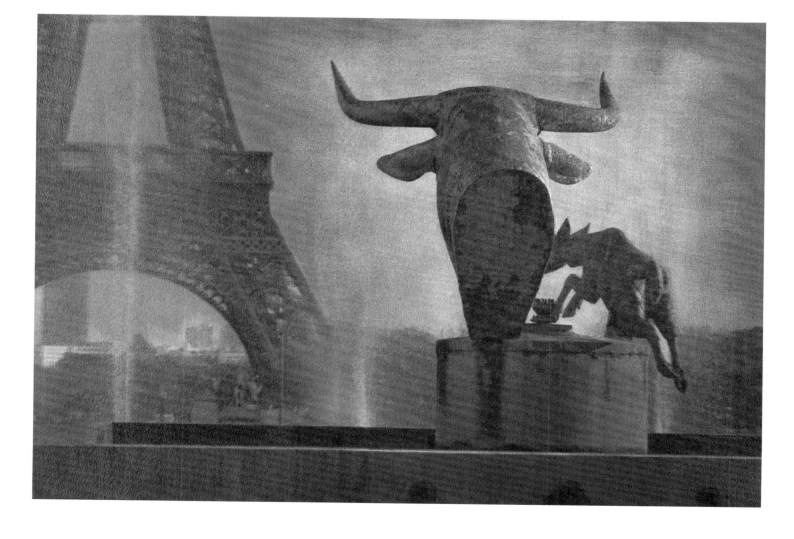

plate 90

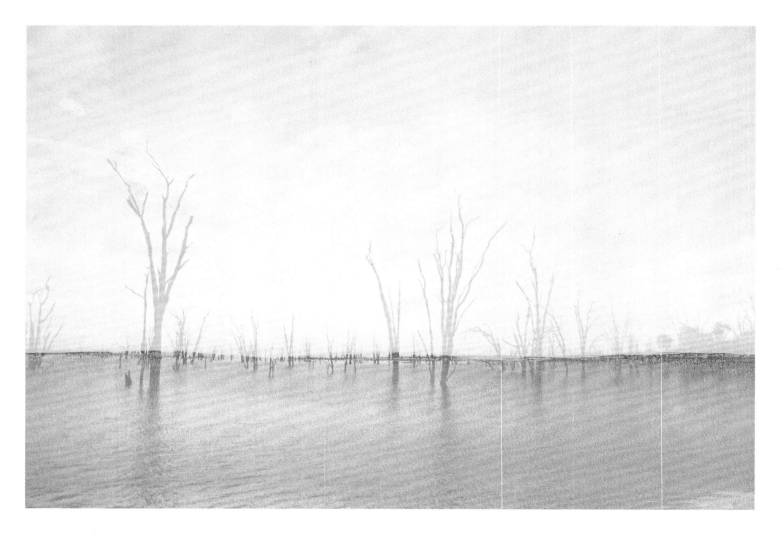

plate 91

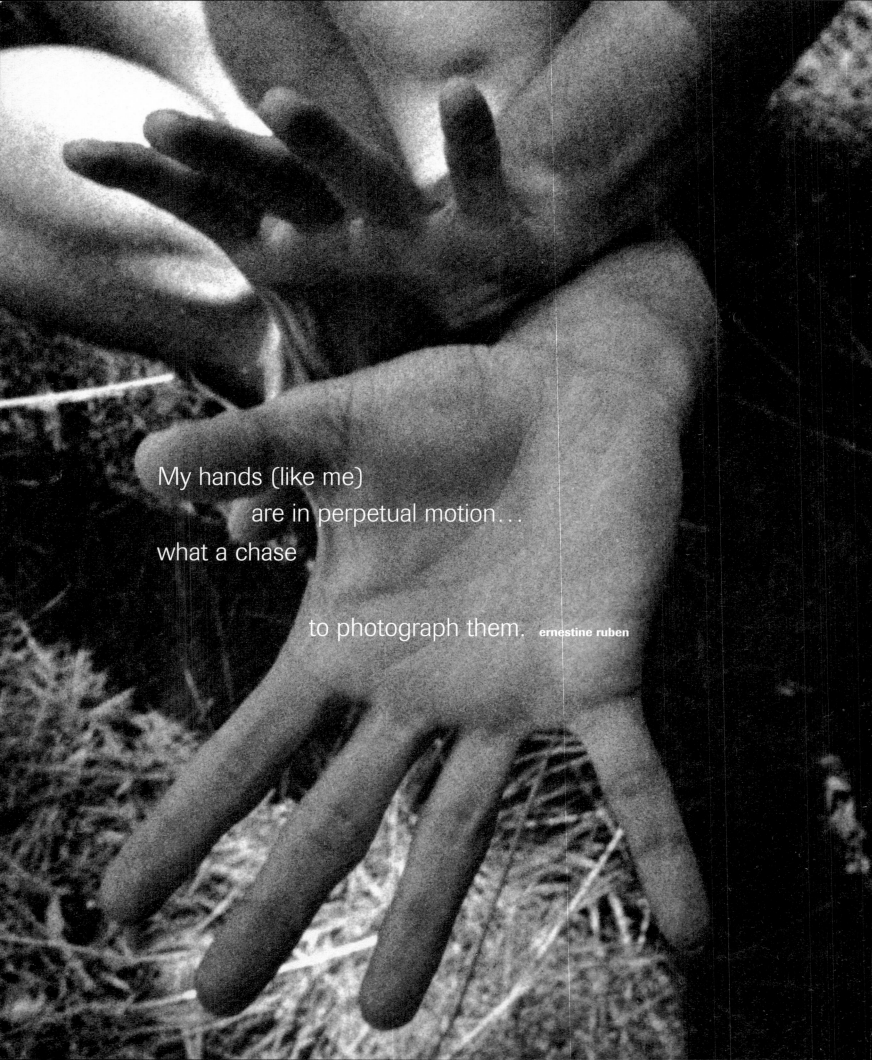

My hands (like me)
are in perpetual motion...
what a chase

to photograph them. ernestine ruben

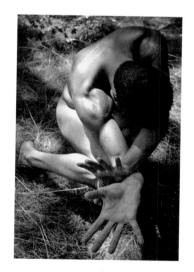

plate 52

plate 53

65 *The Arm of the Muse,* 1994, platinum print, 8 x 12 7/16 IN.

66 *Horizontal Hand of God,* 1997, platinum print, 8 5/16 x 12 10/16 IN.

67 *Ulricke Head Straight Up,* 1998, gum bichromate print, 16 11/16 x 13 3/16 IN.

68 *Spread Eagle in Tree,* 2000, gum bichromate print, 16 12/16 x 11 6/16 IN.

69 *Quiet Lean,* 2000, gum bichromate print, 16 14/16 x 11 2/16 IN.

70 *Horizontal D,* 1998, gum bichromate print, 11 4/16 x 16 12/16 IN.

71 *Heinz Bent to Right,* 1998, gum bichromate print, 16 4/16 x 11 2/16 IN.

72 *Claudia in Flurry,* 1998, gum bichromate print, 15 8/16 x 10 IN.

73 *Diane in Whirl,* 1998, gum bichromate print, 16 9/16 x 10 15/16 IN.

74 *Clay in Mitzpah Ramon,* 1999, silver print on paper pulp, 17 4/16 x 24 4/16 IN.

75 *Dancer's Jaw,* 1987, gelatin silver print on paper pulp, 29 8/16 x 22 8/16 IN.

76 *Burgher with Hand Down,* 1996, silver print on paper pulp, 21 1/2 x 18 1/8 IN.

77 *The Cry with Patina,* 1997, platinum print, 17 9/16 x 11 12/16 IN.

78 *St. John from Burghers of Calais,* 1997, platinum print on paper pulp, 20 5/16 x 18 IN.

79 *Minerva,* 1996, platinum print on paper pulp, 23 3/16 x 19 6/16 IN.

80 *Adam's Profile,* 1996, platinum print on paper pulp, 20 4/16 x 15 14/16 IN.

81 *Burgher Peaking with Hand Up,* 1996, platinum print on paper pulp, 20 x 15 12/16 IN.

82 *Dupuytrens Red,* 1996, platinum print on paper pulp, 20 8/16 x 16 4/16 IN.

83 *Profile of Age of Bronze,* 1996, platinum print on paper pulp, 20 12/16 x 16 8/16 IN.

84 *Balzac in a Frock Coat,* 1996, platinum print on paper pulp, 22 11/16 x 18 IN.

85 *Pierre de Wiessant Beige,* 1997, platinum print on paper pulp, 21 12/16 x 18 IN.

86 *Wirey Tree with Arch,* 1997, platinum print on paper pulp, 20 6/16 x 16 IN.

87 *Dark Twist,* 1996, platinum print on paper pulp, 20 2/16 x 16 3/16 IN.

88 *Arch with Columns,* 1995, platinum print on paper pulp, 12 x 16 IN.

89 *Horse's Head with Knee,* 1998, gum bichromate print, 11 4/16 x 16 12/16 IN.

90 *Eiffel Tower at Trocadero,* 1998, gum bichromate print, 11 1/4 x 16 3/4 IN.

91 *Matusadona,* 2000, gum bichromate and platinum print, 11 x 16 14/16 IN.

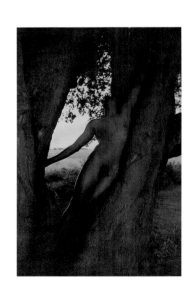
plate 68

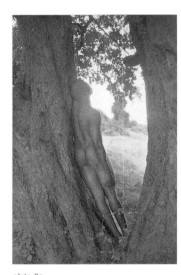
plate 69

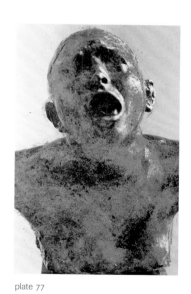

plate 77

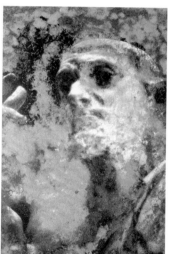

plate 78

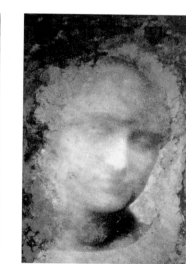

plate 79

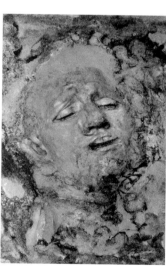

plate 85

ernestine ruben

background
Born: Detroit, Michigan, July 19, 1931
Education: University of Michigan,
Ann Arbor, Michigan,
B.A. History of Art, 1953
Wayne State University, Detroit,
Michigan, M.A. Art Education, 1956

selected solo exhibitions
2000
Cantor Center for Visual Arts,
Stanford University, Palo Alto, California,
Ruben on Rodin
1999
Bratislava, Slovakia, The Month
of Photography, *Rodin and Nudes,*
1999
The John Stevenson Gallery, New York,
*A Lover's Journey, A Retrospective
of 20 Nudes*
1999
Galerie Baudouin Lebon, Paris,
An American in Paris
1997
The Czech Embassy, Washington, D.C.,
The Petra Project
1997
Kathleen Ewing Gallery, Washington, D.C.,
Rodin Revisited and the Petra Project
1997
The Platinum Gallery, New York, *Rodin*
1997
Montgomery Museum of Fine Arts,
Montgomery, Alabama,
Correspondences with Rodin
1997
Maison Européene de la Photographie,
Paris, *Correspondences with Rodin*
1997
Dieu Donné Gallery, New York,
Fusions: Paper and Photography
1997
Prague House of Photography,
Czech Republic
1996
Merrill Lynch Art Gallery, Plainsboro,
New Jersey
1996
The Rodin Museum
of the Philadelphia Museum of Art
1996
The Print Center, Philadelphia
1996
Marist College, Poughkeepsie,
New York
1995
Memorial Gallery, Lehigh University,
Bethlehem, Pennsylvania
1994
Paper Museum, Angoulême, France
1994
The Bellport, Bellport, New York
1993
The Walters Gallery, Rutgers University,
New Brunswick, New Jersey

1992
Gallery 6X7, Mainz, Germany,
ArtEXPO in Frankfurt, Germany
1991
Gallery of Union of Czech Photography,
Prague, Czechoslovakia
1991–1993
Tour of German cities,
Form and Feelings
1990
Sephia Gallery, Brussels, Belgium
1990
Chateau d'Eaux, Toulouse, France
1990
Espace Photo de La Ville de Paris,
Paris, France
1990
Johnson and Johnson, New Brunswick,
New Jersey
1990
ICP Midtown, New York
1989
Forum Gallery, Tarragona, Spain
1989
Canon Image Center,
Amsterdam, Holland
1988
Galerie Charles Sablon, Paris
Mois de la Photo
1988
Centre de la Culture, Amiens, France
1988
Marcuse Pfeifer Gallery,
New York
1988
Museum, Aurillac, France
1988
Wilfrid Israel Museum, Haifa, Israel
1987
La Chambre Claire, Paris
1986
IV Mois de la Photo, Lisieux, France
1986
Ken Damy Gallery,
Milan and Brescia, Italy
1986
Al Ferro di Cavallo, Rome
1986
Salzburg College, Salzburg, Austria
1985
Contemporary Women's Exhibit, Volvic,
France
1985
Musée Fabre, Montpelier, France,
*Journées Internationales de la
Photographie, Corps Humain*
1985
The American Cultural Center,
Brussels, Belgium
1985
Photographic Center of Athens,
Athens
1984
Bateau Lavoir, Paris,
Mois de la Photo, Etre Humain

1984
Le Reverbere, Lyon, France
1984
Tartessos Gallery, Barcelona, Spain,
Primavera Fotografica
1983
Galerie Marion Valentine, Paris
1983
Profoto Gallery, Nuremburg, Germany
1983
Photographer's Gallery, Paule Pia,
Antwerp, Belgium
1983
Rubiner Gallery, Detroit, Michigan
1982–1983
France FNAC Galleries, traveling show
for 18 months, Paris-Montparnasse,
Nice, Toulouse, Marseille, Colmar

selected group exhibitions
2001
Galerie Valerie Cueto, Paris, *Girls on Top*
2000
The Month of Photography, Paris,
Objectif Paris, Galerie Baudoin Lebon
2000
Philadelphia Museum of Art,
Works from the Collection
1999–2000
Lisbon, Lausanne, etc. *The Century
of the Body: Photoworks 1900-2000,*
curated by William Ewing
1999
Detroit Institute of Arts, *Where the Girls
Are: Photographs by Women from the
DIA'S Collection*
1998
Skopelos, Greece, *The Body Electric,*
curated by William Ewing
1997
Montreal Museum of Fine Arts,
Body in the Lens,
curated by William Ewing
1996
Month of Photography, Paris, Le Forum
des Halles, *Image de la Mere*
1996
Contemporary Gallery, Marywood
College, Scranton, Pennsylvania,
Women's Work
1996
Dieu Donné Gallery, New York,
*Innovations and Explorations
in Handmade Paper*
1996
Chateau d'Eaux, Toulouse, France,
D'une Main…l'autre
1994
Phillips Mill Invitational,
New Hope, Pennsylvania
1993
Noyes Museum, *Master Prints from the
Rutgers Center for Innovative Printmaking*
1992
Palais Tokyo, Paris, *En Avion* (with book)

1992
Noyes Museum, *New Jersey
State Invitational*
1989
Salle du Musée Botanique,
Brussels, Belgium
1989
Nikon Live Gallery, Zurich, Switzerland
1988
Graz City Hall, Graz, Austria, *150 years
of Photography*
1988
Musée d'Art Moderne, Paris
Splendeur Misère du Corps
1988
Bibliotheque Nationale, Paris
Mois de la Photo, Ombres de Chair
1988
Lorient, France, *Journées Rencontres, La
Femme's Image* and *Création en France*
1988
Chateau d'Eaux, Toulouse, France,
Artothèque/Acquisitions, 1985–1988
1988
Musée des Beaux Arts, Toulon, France,
Création en France, Le Corps, La Galère
1987
Chateau d'Eaux, Toulouse, France,
Artothèque, Image du Corps
1987
Pinacoteca Comunale, Ravenna, Italy,
*The Male Nude in the 19th and 20th
Centuries,* curated by Peter Weiermair
1987
Morris Museum, Morristown, New
Jersey, *Recent Work by Recipients of
New Jersey State Council on the Arts
Visual Arts Fellowships*
1986
Perros-Guirec, France,
Perros, Ses Rochers
1985
Espace Austerlitz, Paris, *Eros 85*
1984
Rubiner Gallery, Detroit, Michigan
1984
Pavillon des Arts, Paris,
La Photographie Creative, curated by
Jean-Claude Lemagny
1984
Galleries Lafayette, Paris, *Les Plus Belles
Images du Mois de la Photo*
1984
Amsterdam, Holland,
Amsterdam Photo Festival, Object Man,
curated by Giuliana Scime
1993
Nimbus Gallery, Dallas, Texas
1983
Galerie Marion Valentine, Paris
1983
Municipal Museum, Bologna, Italy
1980
Monmouth Gallery, Monmouth College,
New Jersey

commissioned work

1995
Paris, Maison Européenne de la Photographie, 4 panels
1988
Paris, Antenne Deux, *Assiette Anglaise,* Television
1988
Toulon, France, *Photoformance,* commissioned by Musée des Beaux Arts and Henri Mulsant
1984
Paris, France, commissioned by Paris Audiovisuel for the City of Paris, an original creation, an audio-visual installation in the Museum of Modern Art for Le Mois de la Photo. *Collaboration Toulon,* with Daniel Hennemand and original music composed by Guy Printemps.

installations

1996
Maison Européenne de la Photographie, Paris, (permanent)
1995
Jewish Spirits, Wilson and Hall Galleries, Lehigh University, Bethlehem, Pennsylvania
1993
Spirits in the Jewish Cemetery in Prague, a collaboration with architect Meira Kowalsky at the Walters Gallery, Rutgers University, New Brunswick, New Jersey

photoformance

1988
Musée des Beaux Arts, Toulon, France, *Le Marbre Tremble*
1986
Rencontres Internationales de la Photographie, Arles, France
1986
Musée d'Elysée pour la Photographie, Lausanne, Switzerland
1986
American Dance Festival, Durham, North Carolina
1986
23rd Annual National Conference of the Society for Photographic Education, Baltimore, Maryland
1986
Princeton Art Association, Princeton, New Jersey
1986
Bateau Lavoir, Paris, France, *Contact*

collections

—Philadelphia Museum of Art, Philadelphia, Pennsylvania
—Stanford University Museum, Palo Alto, California
—Rodin Museum, Paris, France
—Brandenburgische Kunstsammlungen, Museum für Zeitgenössische Kunst, Cottbus, Germany
—Maison Européenne de la Photographie, Paris, France
—The Museum of Fine Arts, Houston, Texas
—Museum of Modern Art, Paris, France
—Stedlijk Museum, Amsterdam, Holland
—Detroit Institute of Arts, Detroit, Michigan
—Bibliothèque Nationale, Paris, France
—Bibliothèque Historique de la Ville de Paris, Paris, France
—Artothèque, Toulouse, France
—Israel Museum, Jerusalem, Israel
—Johnson and Johnson Corporate Collection, New Jersey
—Merrill Lynch Corporate Collection, New York
—Henry Buhl Collection, New York
—Medicalogic Collection

selected books and catalogues

—*Ruben on Rodin,* Nazraeli Press, 2000
—*Love and Desire,* William Ewing, Chronicle Books, 1999
—*The Art of Enhanced Photography,* Rockport Publishers, 1999
—*21st, The Journal of Contemporary Photography,* The Stinehour Press, 1998
—*The Male Nude,* by David Ledick, Taschen, Germany, 1998
—*Our Grandmothers,* edited by Linda Sunshine, Welcome Enterprises, New York, 1998
—*Eros,* Stewart, Tabori & Chang, New York, 1996
—*Our Mothers: Portraits by 72 Women Photographers,* Viviane Esders, ed., Stewart, Tabori & Chang, New York, 1996
—*Ernestine Ruben: A Book of Photographs,* Nazraeli Press, 1996. Introduction by A. D. Coleman
—*Contemporary Photographers,* Third Edition, Martin Marix Evans, ed., Vladimir Birgus, St. James Press, New York, 1995
—*The Body,* William Ewing, Thames and Hudson, 1994
—*Skin,* by Dorothy Allison, Harper Collins, 1994, front cover photo
—*Ernestine Ruben: A Retrospective Exhibition of Photography,* Rutgers University, 1993 Introduction by Vicki Goldberg
—*Ernestine Ruben,* Catalogue for Municipal Gallery, Toulouse, France, 1990
—*Ernestine Ruben,* Passeport, Espace Photo
—*Ernestine Ruben: Form and Feelings,* Edition Stemmle, Schaffhausen, Switzerland, December 1989
—*Splendeurs et Misères du Corps,* Paris Audiovisuel/International Triannual of Photography, Fribourg, Switzerland, 1988
—*Frauen Sehen Männer,* Peter Weiermair, ed., Verlag Photographie, Schaffhausen, Switzerland, 1988
—*Frauenbilder,* Petra Olschewski, Edition Stemmle, Schaffhausen, Switzerland, 1987
—*Entre Deux,* Paris Audiovisuel, Paris, 1987, photographs by Ernestine Ruben, poetry by Pierre Borhan
—*Akt Fotoschule,* Claus Militz, ed., Verlag Photographie, Schaffhausen, Switzerland, January 1988
—*International Encyclopedia of Photographers,* 1983 to the Present, Michel Auer, Editions Camera Obscura, 1986
—*Photographies du Corp Humain,* Journées Internationales de la Photographie, Montpelier, France, 1985
—*La Photographie Creative, Les Collections de Photographies Contemporaines de la Bibliotheque Nationale,* Jean-Claude Lemagny, Contrejour, Paris, France, 1984
—*Traveling USA,* Deuxieme Rencontre- Art et Cinéma, Quimper, France, May 1984
—*Ernestine Ruben Photographs,* European Photography, Kassel, 1982

selected articles

—*ARTnews,* February 1999, review
—*European Photography,* Number 62, portfolio
—*European Photography,* Number 59, Book Review by Verena von Gagern
—*Princeton Packet,* "Viewing her World...," June 1996, Lifestyle Editor, Ilene Dube
—*Philadelphia Inquirer,* March–April 1996, three articles
—*The Photo Review,* "An Interview with Ernestine Ruben," Harris Sibunruang, Spring 1996
—*American Way,* "Our Mothers," Viviane Esders, ed., May 1996
—*New York Times,* "Sensitive Sculpture and Paradises Inspired by the Shore," Helen Harrison, June 1994
—*Art Matters,* Philadelphia, Helene Ryesky, April 1996
—*Philadelphia City Paper,* Robin Rice, April 1996
—*Interview,* Czech Cultural Magazine, Vladimir Birgus, portfolio, April 1994
—*Newark Star Ledger,* Mitchell Seidel, "Exhibition Focuses on Love for the Human Form," June 1993
—*NewMag,* article with text and photos, Munich, Germany, May 1992
—*Tvorba,* National Czech Cultural Magazine, October 1991
—*Le Monde,* Patrick Roegiers, "A Corps perdu: Les abstractions sculpturales d'Ernestine Ruben," June 26, 1990
—*Le Monde,* Patrick Roegiers, "Deux Architectes du Corps (Ruben and Minkinnen)," Paris, France, November 1988
—*Ombres de Chair,* Jean-Claude Lemagny, program for the Photography Gallery of the Bibliotheque Nationale, Paris, France
—*Nikon News,* #4, "Theme and Discussion on Women and Photography," Zurich, Switzerland, 1987
—*Photographie,* Switzerland, August 1988, portfolio
—*Brutus,* Japan, Spring 1988
—*Clichés,* #40, interview with Jean Claude Lemagny, photo
—*Photographie,* Switzerland, November 1986, portfolio
—*Progresso Fotografico,* Milan, Italy, July/August 1986, portfolio
—*Images,* Centre de la Photographie, Geneva, Switzerland, June 1986, newspaper
—*Photovision,* #13, Madrid, Spain, Object Man, photo
—*Ernestine Ruben,* brochure written by Alain Fleig, Paris, France, November 1984
—*L'Art Vivant,* Paris, France, November 1984
—*Clichés,* #10, Brussels, Belgium, October 1984, portfolio
—*European Photography,* Göttingen, Germany, June 1983, portfolio, text by Ann White
—*Zoom,* Paris and New York editions, Summer 1983, portfolio

representatives

John Stevenson Gallery
338 West 23rd Street
New York, NY 10011-2201

Galerie Baudoin Lebon
38 Rue Sainte Croix de la Bretonnerie
75004 Paris, France

Emily Vickers Productions
11 Van Dyke Road
Hopewell, NJ 08525

201

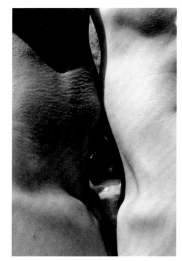

plate 9

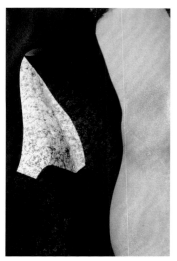

plate 10

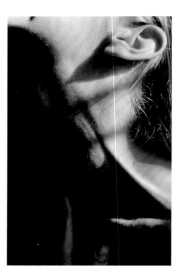

plate 14

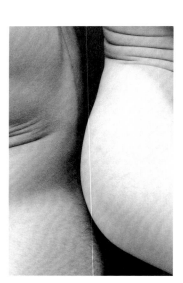

plate 18

notes on contributors

Lyle Rexer was educated at the University of Michigan, Columbia University, and Merton College, Oxford University, which he attended as a Rhodes Scholar. He holds B.A. and M.A. degrees in literature from Columbia University. Rexer is the author (with Roger Ricco and Frank Maresca) of *American Self-Taught: Paintings and Drawings by Outsider Artists* (Knopf, 1993). With his wife, the writer Rachel Klein, he researched and wrote *The American Museum of Natural History: 125 Years of Expedition and Discovery* (Abrams, 1995), a comprehensive presentation of the Museum's field work based on its archives of 60,000 photographs. *Animalerie,* the title essay on the work of photographer Jayne Hinds Bidaut, will be published in 2001 by University of Texas, Southwestern. *The Antiquarian Avant-Garde: The New Wave in Old Process Photography* (Abrams) is scheduled for publication in Spring 2002. Rexer writes on art and photography for a variety of publications, including *The New York Times, Art in America, Aperture, Graphis,* and *Metropolis.*

James Christen Steward studied at the University of Virginia, the Sorbonne, and the Institute of Fine Arts at New York University. He received his D.Phil. in the history of art from Trinity College, Oxford University where he studied with the eminent art historian Francis Haskell. Steward is the author of *The New Child: British Art and the Origins of Modern Childhood, 1730–1830* (University of Washington Press, 1995), and editor of and contributor to *The Mask of Venice: Masking, Theater, and Identity in the Art of Tiepolo and His Time* (University of Washington Press, 1996) and *When Time Began to Rant and Rage: Figurative Painting from Twentieth-Century Ireland* (Merrell Holberton/Rizzoli, 1998). He is a frequent writer on contemporary art and photography, including "The Photographs of Sally Mann and the Spaces of Childhood," which appeared in the *Michigan Quarterly Review* (Spring 2000). Formerly Chief Curator of the Berkeley Art Museum, Dr. Steward is director of the University of Michigan Museum of Art and Associate Professor of Art History at the University of Michigan.

Serge Tisseron received a doctorate in medicine from the University of Lyon, and a doctorate in psychology from the University of Paris–Nanterre. Dr. Tisseron's academic studies led him to an interest in the relationships humans form with the objects in their daily lives, the secret meanings embedded in such objects, and memory. He is the author of numerous volumes on art and psychology, including *Psychanalyse de l'image (Psychoanalysis of the Image,* Dunod, 1995), *Le Bonheur dans l'image (Happiness in the Image,* Les Empecheurs de penser en rond, 1996), and *Le Mystère de la chambre claire: Photographrie et inconscient (The Mystery of the Camera Lucida: Photography and the Unconscious,* Les Belles Lettres, 1996, Flammarion, 1999). He has also published frequently on psychology and society, focusing on concerns such as the role of shame in human behavior and the influence of film and television on juvenile behavior. Dr. Tisseron is a practicing psychiatrist and psychoanalyst, specializing in family issues in Paris, where he also teaches at the University of Paris VII.

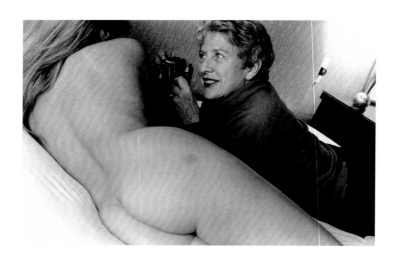